DISASTER
IN
LAWRENCE

Boston Journal.

TUESDAY EVENING, JAN. 17, 1860

The Lawrence Disaster.

DAY OF FASTING AND PRAYER.

BUSINESS SUSPENDED.

MORE DONATIONS.

SERVICES IN THE CHURCHES.

Another Body Recovered.

DISASTER
IN
LAWRENCE

The Fall of the Pemberton Mill

ALVIN F. OICKLE

Charleston London

THE
History
PRESS

Published by The History Press
Charleston, SC 29403
www.historypress.net

Cover image: Illustration, from *Illustrated News of London*, showing rescue teams removing casualties after the fall of the Pemberton Mill. *Courtesy of Library of Congress Prints and Photographs Division, LC-USZ62-92189.*

First published 2008

Manufactured in the United Kingdom

ISBN 978.1.59629.506.3

Library of Congress Cataloging-in-Publication Data

Oickle, Alvin F.
Disaster in Lawrence : the fall of Pemberton Mill / Alvin F. Oickle.
p. cm.
Includes bibliographical references.
ISBN 978-1-59629-506-3
1. Lawrence (Mass.)--History--19th century. 2. Disasters--Massachusetts--Lawrence--History--19th century.
3. Building failures--Massachusetts--Lawrence--History--19th century. 4. Fires--Massachusetts--Lawrence-
-History--19th century. 5. Pemberton Manufacturing Company--History. 6. Pemberton Manufacturing
Company--Fire, 1860. 7. Disasters--Massachusetts--History. I. Title.
F74.L4O37 2008
974.4'503--dc22
 2008016091

The history of textiles is fundamentally a story about international commerce in goods and ideas. It is therefore a story about exploitation as well as exchange, social disruption as well as entrepreneurship, violence as well as aesthetics.

— Laurel Thatcher Ulrich

Contents

Acknowledgements

My interest in writing this book was sparked in 1999 with an item in the *Boston Globe*. The writer gave a few facts about the collapse of the Pemberton Mill in Lawrence, Massachusetts. That was enough to intrigue me. Within a week, I visited the office of the city clerk. An assistant pulled from an inner vault a ledger marked with the florid handwriting of a century past. Reading the haunting list of dead was enough for me to determine I had to write this story.

Anyone who has gone through the effort of tracking down events far back in time knows how necessary it is to have assistance in piecing patches of information into a narrative quilt. Two professionals were especially helpful. Louise Sandberg, curator of Special Collections at the Lawrence Public Library, contributed her huge knowledge of the city's history as well as her energy and encouragement. She located and made available dozens of fragile records. When I first met Patricia Reeve, she had already traveled some of the research paths I was visiting. Her interest is in the history of working people, and she was preparing to devote a chapter in her doctoral dissertation to the Pemberton story. She shared copies of material she had acquired and became a co-worker in finding and interpreting information about mid-nineteenth-century American culture.

It would not be an overstatement to say that Louise and Patricia—and my late wife, Lois A. Oickle—provided at times the courage and, yes, the inspiration that I needed to keep going. Lois made many of the trips with me, scouring dim stacks for a small volume with a virtually indiscernible name on the cover. And, as she had been with other books I have written, she was my best editor and adviser.

Paul A. Faler, retired professor of history at the University of Massachusetts–Boston, suggested readings and provided examples of tight writing.

Excellent assistance came from the professionals at the Osborne Library at the American Textile History Museum in Lowell, Massachusetts. They are Clare M. Sheridan—librarian for books, manuscripts and images—and Anne M. Cadrette, then assistant librarian. This facility has an impressive collection of historical records and objects from the early textile industry and makes it available for research.

Among others who contributed to my gathering of information were Patricia Janesane, then executive director of the Lawrence History Center–Immigrant City

ACKNOWLEDGEMENTS

Archives; James M. Jacobs, director at St. Mary–Immaculate Conception Cemetery in Lawrence; Margaret L. Winslow, curator of historical collections at Mount Auburn Cemetery in Cambridge, Massachusetts; Jo August Hills, librarian at Lowell National Historical Park; Martha Mayo, librarian at the Center for Lowell Studies at University of Massachusetts–Lowell; Beverly Hill Perna, museum education specialist for Tsongas Industrial History Center/University of Massachusetts–Lowell; and Paula Devlin-Wood, a teacher-writer in Raymond, New Hampshire, who is descended from the Hanlon sisters of 1860.

It would be unforgivable not to cite the work of Clarisse Poirier, associate professor of history at Merrimack College in North Andover, Massachusetts. Her doctoral dissertation and later published writing thoroughly cover the Pemberton Mill's collapse and much more.

There are others whom I have not named, but I trust they know how indebted I am to them. My family and many friends accepted and encouraged the great investments of my time on this project. Having such support was a major comfort in the tedious work of making this quilt, and I thank every one of them.

Alvin F. Oickle
Dennisport, Massachusetts
April 2008

Introduction

Sometimes it takes a disaster to make clear a need that was always there and even apparent. Such was the case as America's industrial revolution was clanging into high gear in the textile mills of New England in the mid-nineteenth century.

Such a disaster occurred in Lawrence, Massachusetts, in 1860. On a cold winter afternoon, one of the new "monster mills" along the Merrimack River collapsed in not much longer than a heartbeat. More than six hundred people were at work, most of them in the main mill. Many were immigrants from the British Isles, Ireland and Canada. More than half were females—women and girls twelve and younger. Before rescuers could explore the thousands of tons of heavy machinery and building materials, fires broke out and roared through banks of cotton and planking covered with machine oil.

When the final count was made, months later, the casualties from that horrid night at the Pemberton Mill exceeded four hundred. Among the one hundred dead were people representing a cross section of the population. There was a city council member whose broken pocket watch made official the time of the calamity. There were Irish mothers and men from all over New England. And there were the children. Two little girls, in their first day of work that cold Monday, were never to hold their earnings, about a half-dollar each for ten hours of work.

Sympathetic reaction came quickly from around the United States. Within two weeks, so much money and other gifts had been sent to the city that the mayor asked for an end to the generosity.

Speed and generosity were not applied to improve employees' working conditions. The laggard legislature of Massachusetts refused action that year. As would be the case in other states after similar industrial accidents, politicians were slow to require owners to build safer factories. Thousands of workers would die or suffer injury before rigorous safety standards were established. The annual death toll has been estimated at thirty-five thousand over the twenty-year span ending the nineteenth century.

There is no happy ending to the story of the Pemberton Mill. The Pemberton dead were long buried before improved standards in employee safety had a significant impact in Massachusetts and other manufacturing states. That there was improvement is history. That it came only years after the disaster in an unhurried way contributes to the sadness that hangs over the story of the Pemberton Mill.

"Like Waves
of the Sea"

The writer does not seek to revive recollections of an occurrence that citizens would, if possible, consign to oblivion; but the intense interest excited by the tragedy herein described was too profound, lasting, and universal, in New England and throughout the entire country, to be forgotten.
—Robert H. Tewksbury. Lawrence, Massachusetts, January 10, 1900

What's that?" James Tatterson called out. A rumbling noise was coming from above him on the river end of the Pemberton Mill.

Tatterson had begun work only two weeks before in the Lower Weaving Room, where his brother John was overseer. The sound and sudden motion interrupted his instruction from Benjamin Adams, the second hand in another department. They were discussing "some flannel looms."

What *was* this thundering noise?

Adams never had time to answer, nor to protect himself from injury.

Elizabeth Fish, at her Lower Weaving Room machine closer to the North Canal, heard "an overpowering roaring and crackling sound." John Ward, working in the second-floor Carding Room, described "a loud, thundering crash over my head, and, looking up, I saw the shafting coming down upon us all over the room."

In the half-dozen auxiliary buildings crowding the Pemberton lot, workers stopped to listen to the sounds exploding from the main mill. James M. Reed was in the free-standing River Building on the north bank of the Merrimack River. "The sound," he recalled, "was one continuous roar, commencing louder as it continued."

Adams and Tatterson did not have to look far to find the source of the thumping, tearing sounds. The six-story, brick south wall and all of the floors above the first in this giant factory were falling toward them. Like the proverbial dominoes, thousands of tons of crashing building materials and machinery were cascading the entire 284 feet toward the north wall.

The Pemberton Mill was "coming down like waves of the sea," Rosanna Kenney was to say. Buel W. Dean, standing nearly a hundred yards north of Adams and Tatterson, was within two feet of the north wall. Dean said, "I looked towards the south and saw the floors near the other end coming down…I should think it was not over half a minute from the time the first noise was heard until the mill was all down."

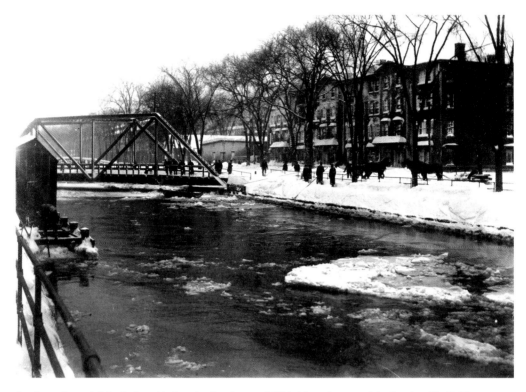

Ice flows through North Canal below the Pemberton Mill bridge. *Courtesy of the American Textile History Museum, Lowell, Massachusetts.*

This winter was cold, filling Lawrence's streets with snow. Men with teams of horses had made Canal Street more passable as millhands arrived in the dark. Monday through Saturday, year-round, more than nine hundred employees crossed a bridge over the North Canal. As they stomped the wood planking to kick away the winter's cold clinging to their boots, they were heading for the Pemberton Mill, one of five brick factories on the north side of the Merrimack River. From as far as three miles away, the operatives came to work an hour before dawn and departed several hours after the sun had set each winter day.

As many as half of the Pemberton Manufacturing Company's employees lived in a huge boardinghouse directly across Canal Street. On this cold winter morning, snow weighed down the flat roofing that protected the six Canal Street entrances to the boardinghouse. In the street, unpacked snow was being shoved beneath railings onto ice covering the canal. The ice was thick enough to support, without cracking, the weight of this new snow and even a crowd of people.

This North Canal ran from the gatehouse—at the one-hundred-foot-wide, twenty-four rack-and-pinion gates on the Merrimack River—one mile to a sixty-foot-wide wasteway at the Spicket River. The canal water, moving fast even beneath winter's hard coat, had a more important task than removing snow and ice. It was routed through a second set of heavy metal filters at factory gates in the canal walls. From there, now clear

of debris, the water rushed through the Pemberton's penstock pipes into the mill's power system three hundred feet away in the River Building.

Lawrence had reason to greet the new year with more optimism than in the past few years. For the families of Pemberton employees, January brought the start of what they hoped would be a very happy year. Factory business had picked up over the months since the reopening in 1858. So far there had been no signs of letup. The owners were even considering expansion into unused space on the sixth ("attic") floor of the main building.

This bright outlook was shared by more than six thousand men, women and children employed in four other factories on the North Canal. The Washington Mills, until recently called Bay State and the biggest in Lawrence, was considered the largest of its

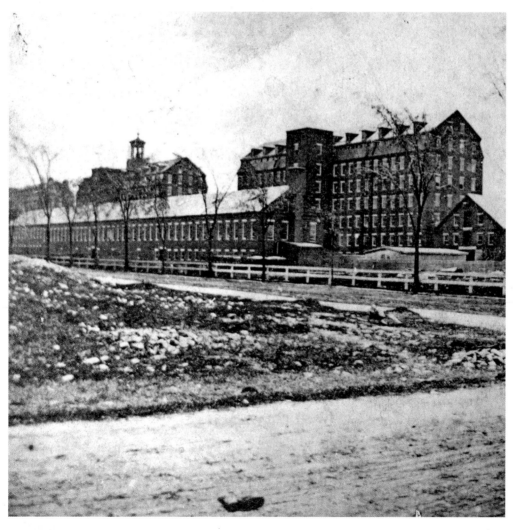

Washington Mill, formerly the Bay State Mill, was a near neighbor of the Pemberton. *Courtesy of the Lawrence Public Library.*

kind in the world. The Washington employed twenty-five hundred. The Pacific—with two thousand on the payroll and called the largest of *its* kind in the United States—and the Atlantic, with fifteen hundred, were also turning out tons of cotton and wool fabrics every day. Even the tiny Duck Mill, with only two hundred employees on its rolls, was in full production.

New England textile manufacturers at the dawn of the 1860s were coming off the best year in their history. In 1859, the mills had turned out 856 million yards of goods. The old record was 775 million, set in 1856. The Panic of 1857 had cut production to 661 million, and much of the loss had been regained in 1858 at 766 million yards.

Considering that a staggering recession had contributed to the closing of many Massachusetts mills from autumn of 1857 to spring of 1858, Lawrence textile workers in early 1860 could not be blamed if they felt a need for reassurance that good times were here to stay. Yet all the signs of continued employment *were* there to be measured. The Pemberton, with nearly 650 looms and 2,900 spindles, was at capacity. In full operation, the mill used 60,000 pounds of cotton every week. A week's production of fancy textiles—cambric and cottonades, denims and flannels—would exceed 115,000 yards. The *New York Times* noted that the Pemberton manufactured "a greater variety of work than in any other mill in this or any other country. Its appointments were the most perfect that the ingenuity of mechanics could devise and…[it] was one of the best paying properties of the State."

All things, as always, were relative. Even in the best of times, some families struggled. Mary Ann Hamilton, a widow, and her three children had been scraping by in Lawrence since arriving from their native England only a few months ago. They were no doubt pleased but nervous that Mary Ann's fourteen-year-old daughter Margaret was to begin work on Tuesday, January 10, at the Pemberton. At last, the family would have a steady income, and Mrs. Hamilton would be able to devote full attention to her family.

For Mary Bailey, there were mixed feelings. She and her husband Joseph were expecting a baby. But then, she would be unable to work, perhaps for months. She and Joe were bringing in more than fifty dollars a month at the Pemberton. With Mary out of work, and with the expenses of a new family member, the Baileys would find life more difficult.

By almost any standards, all the mill workers in this new year of optimism could be considered in poor financial shape. Cynthia McCarthy, for example, had come east to see friends, ran out of money and was now a Pemberton operative, working to save enough money to return to her husband in Wisconsin. John Phalen had ten-and-a-half days of work under his belt, and William Kane had twelve.

The word "poverty" was to be used openly in describing two new families from Nova Scotia. While some of them worked at the Pemberton, they, like the other employees, had not yet received their monthly pay. In the apartment these eight Canadians shared, they had only one bed.

The people who did the counting saw encouraging signs. Lawrence's population had increased by more than 1,500 over the 16,000 logged in 1859, a gain of more than 500 registered voters, to 3,609, and nearly as many in schools, now nearly 3,200.

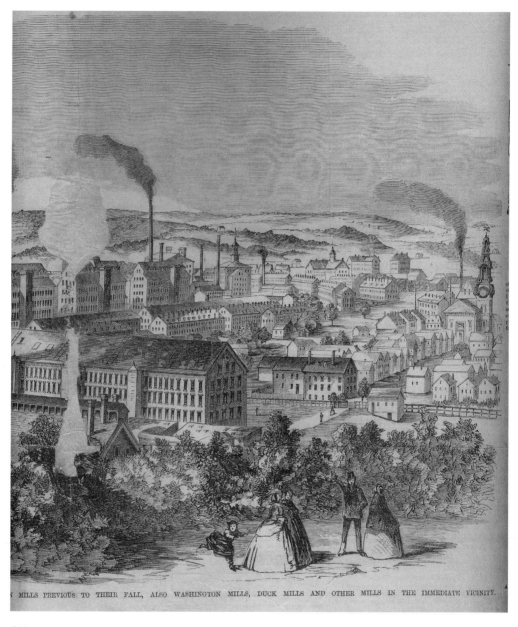

N MILLS PREVIOUS TO THEIR FALL, ALSO WASHINGTON MILLS, DUCK MILLS AND OTHER MILLS IN THE IMMEDIATE VICINITY.

Chimneys, church spires and the City Hall tower mark the flourishing city of Lawrence. Leslie's Illustrated Newspaper, *January 28, 1860. Courtesy of the Lawrence Public Library.*

A heavy downpour of rain that first week in 1860 troubled Maria Yeaton. Working on a loom in the second floor Weaving Room in the Pemberton's Cotton House, she asked Elbert S. Moses, overseer, if the Merrimack River might rise to the freshet stage. "Why do you ask?" Moses said. Maria Yeaton answered, "Because we are always afraid of the big mill when the water is high."

For others, it was the same old routine. Henry Studley was on duty once more to readjust shafting. He recalled, "We moved them a few inches, from thirteen to twenty, towards the center of the mill."

"Perfect" was the rating given by John R. Rollins. In his chapter on Lawrence in D. Hamilton Hurd's *History of Middlesex County, Massachusetts*, Rollins wrote: "The machinery had never been running more perfectly during the six years it had been in operation." Yes, it was a new year, and the good old/bad old times had returned to this young Merrimack River city as it helped to create the American Industrial Revolution.

While hundreds worked for the Pemberton, turnover was moderate. Women and children did not move around in jobs, primarily because there were few workplaces open to them. Nevertheless, there were bound to be a few newcomers every week and job seekers almost every day. Two newly hired girls were at their first day of work as "learners" on January 10. As daylight faded, Margaret Hamilton was in the fifth-floor Spooling Room. She would have to work the rest of this day and all the following day to earn her first dollar in America. The three dollars she could earn in a week would provide most of the support for her family. Also at her first day of work was Ann Smith, a Boston resident who had been given living quarters at a company boardinghouse, "No. 5 Pemberton Corporation."

Not much more of a Pemberton veteran than Margaret or Ann was a youngster with a week's work behind him. Charles Morgan had come with his widowed mother from Ireland.

In a better world, children like Margaret, Ann and Charles would not have been locked into the dingy toil of making textiles for the Pemberton Mill. They would have headed off to school. Harry Kemble Oliver, school superintendent, saw a dark side to the city's growth. In his 1859 annual report, he wrote:

> There are so many children and youth of both sexes in our city, who by their absence from the School-room, or irregular attendance at School, have failed to profit by the privileges which our school system render alike accessible to the poor as well as the rich, to the foreign as well as the home-born…so many…roam our streets and acquire daily lessons in the theory and practice of wickedness.

America was a land still stretching for goals barely beyond its reach. Definitions were still uncertain, values not always determined. And yet, it was easy to see that the gap between the rich and the poor was vast.

Lowell attorney and politician Benjamin M. Butler considered it "natural [that] stockholders wanted large profits and they were having them. The mills were exceedingly profitable. They were the highest class of investment in the State, and their surplus funds devoted to the enlargement of their properties were simply enormous."

Some thought this exploitation was unconscionable. One such person was Francis Cabot Lowell. He had returned to America from a visit to Europe determined to create a business that did not exploit its workers. In Great Britain, he had seen the revolting conditions that were accepted.

Benjamin Butler described Americans' owner-management roles:

> *The business affairs of these productive establishments were carried on precisely alike. The bells of each rang their laborers in and out of the mills; called them to arise in the morning and take their breakfast by candlelight, save in the very longest days; rang them to take their supper at half-past seven in the evening by such light as might be at that hour. An intermission of thirty minutes only was allowed for dinner. By means of carefully adjusted time-pieces, all the bells struck as nearly in unison as was possible without the aid of electricity. No laboring man or woman who had been employed by one corporation could be employed in any other in the city without a pass from the first.*

As nightfall arrived in Lawrence on January 10, most Pemberton employees were likely considering themselves fortunate to have work. We can imagine them looking forward to payday. The company owed them wages for five weeks of work.

Shadows in the Afternoon

The girls came from the country to work in the mills to get a few hundred dollars to remove the mortgage on the home place; the young men came for the same purpose, or to get the means of starting in some other business. Nobody came…in those days to become a resident operative as a life business.
—Benjamin F. Butler

As the waning light brought afternoon shadows to the Pemberton Mill, a job applicant with darkness in her heart was seated in the office area. Mary Desney had recently arrived from Anderson, Scotland. A Lawrence friend had urged the young woman to apply for work at the Pemberton, so she waited while a search was conducted for the overseer in charge of hiring. But Mary Desney's patience did not last. Perhaps only because she was a newcomer, Mary felt compelled to leave without meeting the overseer. She had a "fearful presentiment of impending danger," she was to tell an interviewer. The time was about 4:35 p.m. when she went out into the cold.

Also leaving about then was a young factory hand. Margaret Ryan, not yet in her teen years, had argued with her department's overseer. In anger, she had thrown a bobbin at him and fled the building.

Beyond the factory, life was going on as usual. A Chelsea woman was en route to Lawrence for the first time in years to visit her sister, Alice Cullen. Lawrence High School students were just finishing the day's second session. In the shanties and modest tenements of Lawrence, late afternoon was the time for women at home to stoke the fires in kitchen stoves and prepare supper for family breadwinners. Ellen Murphy had three children coming home: a twenty-year-old daughter who worked at the Atlantic Mills; a son, aged fifteen, employed at the Duck Mill and a twelve-year-old boy who earned one and a half dollars a week at the Pemberton. Catherine Rooks would prepare dinner when she returned home, like single mothers and other women whose husbands weren't much help, even when unemployed, as Mr. Rooks was now.

In his office, Jonathan F.C. Hayes was working on the next weekly issue of the *Lawrence Courier*, the city's first newspaper. From a building nearby, Dr. William D. Lamb could easily glance out a window at the hulk of the Pemberton factory. Like many others among the city's leaders, he was young—only thirty-six. He had presided over the new community's first town meeting in 1847, had served on the first school committee and

had just concluded a year as president. A large man with a trimmed beard and easy-going manner, Lamb was a physician with an active practice. For the past six years, he had served as a county coroner. The position took little of his time. As a forerunner of Massachusetts's district medical examiner, the coroner was required to examine the bodies of victims of accidents and homicide.

By late afternoon, a busy physician could be expected to pause, to catch his breath. Likewise, over the course of a twelve-hour workday, mill workers might take a break midway between the noontime dinner hour and quitting time. Matthew Ryan, working in the Pemberton's fourth-floor Spinning Room, was showing off for Harriet Brackett, a young worker in the next-door Washington Mill. She told the *Lawrence Telegram* years later: "We were making grimaces and signaling each other." Ryan had fashioned a beard, moustache and sideburn whiskers out of cotton.

The development of Lawrence may be laid to three key men—Daniel Saunders, Abbott Lawrence and Charles S. Storrow—and to a plan; not just "any plan," really, but to a plan that followed methods originated at Lowell. This plan was based on simple reality—own and control the use of the waterpower needed to run the machinery that created cotton and wool fabrics. Most prominent of these figures in developing Lawrence was Daniel Saunders, a one-time farm worker from Salem, New Hampshire. A veteran risk-taker, he had over the years bought, founded and operated several small textile mills in southern New Hampshire and near the Merrimack River in Andover, Massachusetts. Journalist Horace A. Wadsworth credits the founding of Lawrence to Saunders's chance acquisition of "an old plan for a canal from Lowell to tide water in the Merrimack River."

During the 1830s and 1840s, Saunders and his son, an attorney also named Daniel, patiently began acquiring land on each side of the Merrimack River in Andover and Methuen. Much of the land was claimed through conditional deeds. "Earnest money," often five or ten dollars, was offered for a three-year option to buy at an agreed price.

To bring Daniel Saunders's dream to reality, he would need much more capital than he could command. And so, Saunders, Samuel Lawrence and colleagues followed another pattern: they turned to relatives and close friends. Boston's social elite formed a tight-knit group of intermarried "Brahmins." Oliver Wendell Holmes borrowed the term from the sacred ritualists of India in a novel that introduces a young Bostonian: "He comes of the Brahmin caste of New England. This is the harmless, inoffensive, untitled aristocracy." The "caste" of real-life Brahmins included the families of Cabot, Lowell and Lawrence, and Amory, Appleton, Jackson and Storrow.

In 1845, the new group formed the Essex Company—named for the county in which Lowell already had the largest population. Nathan Appleton and John Amory Lowell each acquired $50,000 in stock. Abbott Lawrence, quick and generous, pledged $100,000. It seemed natural, then, that when the time came to organize the Essex Company, Abbott Lawrence was elected the first president. Until his death twelve years later, he was the only president.

With Saunders and Abbott Lawrence, the third key figure in the founding of the new enterprise was a Canadian-born railroad man. Like others, he was a Harvard graduate

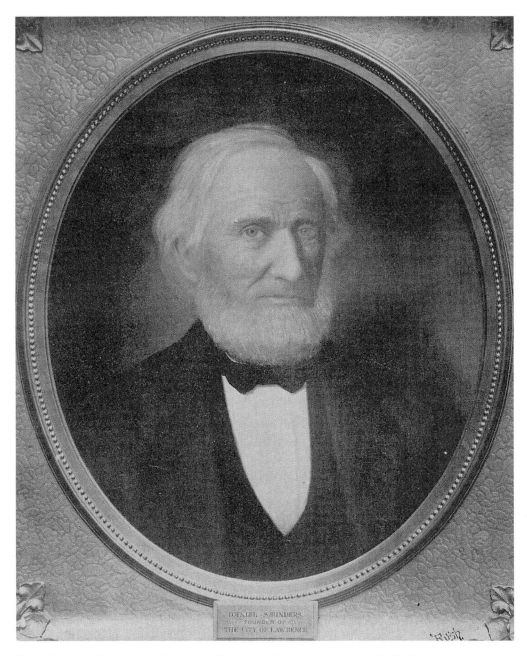

Daniel Saunders Sr., founder of the city of Lawrence. *Courtesy of the Lawrence Public Library.*

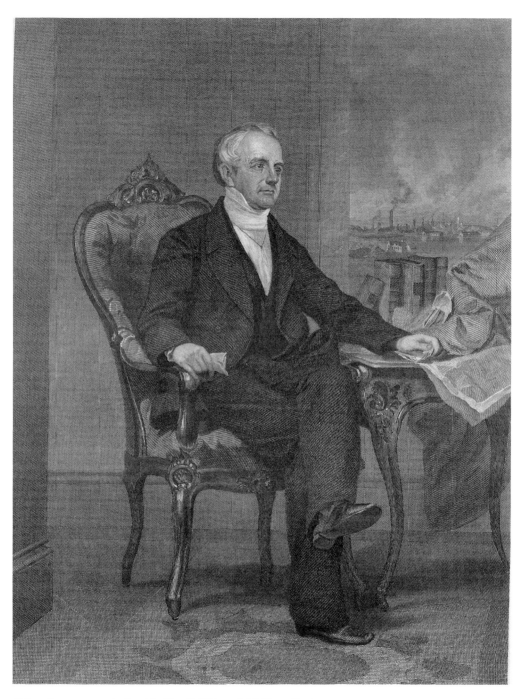

Abbott Lawrence as depicted in Hurd's *History of Middlesex County.*

and had married into the "Brahmin" caste. His wife was the former Lydia Cabot Jackson. Charles Storrow, however, brought much more than spousal connection to the ambitious and aggressive Essex Company leadership. At thirty-six, he was already a successful engineer.

Controlling the Merrimack River at Bodwell's Falls was the first major project for the Essex Company. The action that followed the naming of the city for the Lawrence family moved swiftly. By August 1, 1845, a large work force was excavating for the Great Stone Dam. To help with much of the first decade of building, the Essex Company brought in a former Army Corps of Engineers captain, Charles Henry Bigelow. An 1835 West Point graduate, Bigelow had assisted with the construction of Fort Warren and supervised the building of Fort Independence, both in Boston Harbor. After leaving the Army "for personal reasons" in 1846, he apparently had two job offers, one as manager of the York Mills in Saco, Maine.

Storrow recruited Bigelow as his successor as the Essex Company's chief engineer. Bigelow was immediately occupied with company work outside the office. He took over supervision of two major projects—the Great Stone Dam and the North Canal—that would be the engine driving the new city's development.

On the narrow, mile-long island between river and canal, mills would be designed and constructed under the direction of Bigelow, and their products would be known around the world. As virtually his first "solo" job, Bigelow had designed and supervised construction of the Essex Company's granite office building. It stands today where he built it, at 6 Essex Street, and is in use as the Lawrence History Center–Immigrant City Archives. The project that would bring him lasting recognition, however, was the Great

VIEW OF THE FALLS, COTTON MILLS, FACTORIES, ETC., AT LAWRENCE, MASS.

The Great Stone Dam on the Merrimack River, Lawrence. *Courtesy of the Lawrence Public Library.*

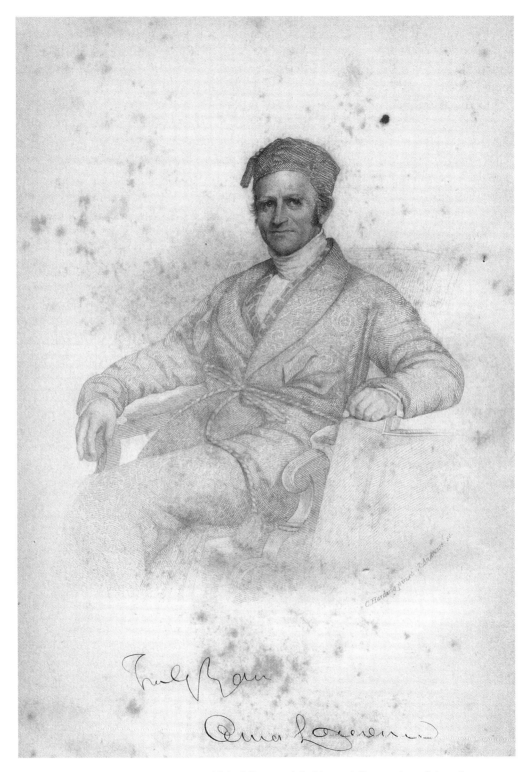

Drawing of Amos Lawrence, from the published *Extracts of the Diary and Correspondence of Amos Lawrence.*

Stone Dam. Bigelow, as the Essex Company's chief architect-engineer and construction supervisor, was being permitted the authority to order all building materials and hire the companies and workers to carry out his instructions. He could be recognized as having joined Saunders, Lawrence and Storrow as the city's key decision-makers.

In the early years, the Essex Company was busy creating the industrial complex. Abbott Lawrence, returning from London and his position as United States ambassador to Great Britain, saw a new investment opportunity. He helped finance and manage what came to be called the Upper Pacific Mills. Incorporated in 1853, the Pacific and Abbott Lawrence had help from his nephew, Amos A. Lawrence, then treasurer of Harvard University.

The Pacific Mills began production in 1853 at the same time that construction of Isaac Thatcher's Lawrence Duck Company was being completed and when work was beginning on the Pemberton. The rails of the Boston & Maine line running parallel to the canal were kept shiny with daily deliveries of building and production supplies.

Some historians believe Lawrence was created at the wrong time. They cite market conditions going bad and a severe depression after years of prosperity. Although two new mills, the Pacific (1852) and Pemberton (1854), helped bring business to the Essex Company, more funds were needed. Abbott Lawrence increased his investment in the city to more than a million dollars. This downturn would be repeated even more dramatically. The *New York Times* reported how that event affected Lawrence: "Its growth, up to the Panic of 1857, has been unparalleled, even among the mushroom cities of the great West. This crisis, however, impeded its growth greatly." In 1857, John A. Lowell and associates had been forced to close and sell the Pemberton Mill at auction to George Howe and David Nevins. The new owners had the factory in full production as, the *Times* continued, "The city was just recovering from that terrible depression when it was again checked by the Pemberton calamity."

The Fall of the Pemberton Mill

Heard ye that wail of fearful woe,
Loud bursting on the air!
Listen! Oh listen, to those groans
And shrieks of wild despair!

—Jason E. Cowden

On the second Tuesday in January of 1860, New England was well into the freeze-then-melt temperature slides of winter weather. The first week's cold had been replaced by mild, pleasant days. The few inches of snow covering the ground were melting. The Pemberton's main mill roof was dry—at least the portion over the fifth-floor Dressing Room. This area "was kept at a high temperature, which would melt the snow off soon," Alonzo N. Wing explained. He was in charge of winding operations. For that matter, the gutters draining water from the roof were also empty of snow. Jesse Glover went there "to have some snow shoveled out of the gutters."

Now that the "shortest" day of the winter was three weeks past, darkness was coming a minute or two later each day. Mills typically had many windows, all of them large, in order to capture as much daylight as possible, and the Pemberton, when constructed six years before, was considered a model of efficiency. Its windows were unusually large for that purpose. But ten hours of daylight were not enough. The mill's workday went on for twelve hours, until seven o'clock in the evening. By 4:30 p.m. on January 10, men assigned to lighting lamps were making their rounds. In the Boiler House, Henry Nice was putting a new wick in a lamp. Tobias W. Roberts, the second hand, and John Ward, working in the second-floor Carding Room, were slightly behind schedule. They had lighted only a few burners by 4:45 p.m.

In the first-floor offices in "the Wing," Frederick E. Clarke, the cashier in charge of payrolls and accounts, and his clerk, Henry L. Newhall, were working on the "pay list." Newhall recalled later, "I had in my possession the last payroll [that is, the latest pay list]. I was writing pay envelopes and left the payroll in the desk. There was one payroll [record] in the safe, which was made up in August."

Paydays came only twelve times a year in mill towns. Benjamin Butler, the Lowell attorney who would become Massachusetts governor, explained: "On a given Saturday

in each month, every man, woman, and child should be paid the wages earned the preceding month, in cash, without any deduction or diminution."

As the dull winter sun moved toward the horizon, John E. Chase, the agent who ran the Pemberton factory, was touring the workrooms with George Howe. As it happened, both co-owners visited the factory on January 10. Howe and Nevins were not like John A. Lowell and the other original Pemberton owners; they were not invisible investors. Quite the opposite—by their close, personal direction, they were nurturing to a profit-making status a business that had gone under two years earlier, partly because of the Panic of 1857–derived national recession and partly because of losses laid to Samuel Lawrence when he headed the Boston firm serving as the Pemberton's sales agency.

The new owners were experienced in two businesses essential to success—banks and mills. They were across-the-street banking neighbors in Boston, Nevins & Co. at 10 City Exchange and Howe with State Bank at 13 City Exchange. Nevins, who owned a cotton mill in the nearby town of Methuen, was "managing director" from the beginning of his association with the Pemberton. Howe, a Roxbury resident, was a veteran manufacturing administrator, generally seen as a man more interested in the accounting books than in the looms and spindles. Howe was an associate of Pemberton founder John A. Lowell. They served together as directors of the National Insurance Company in Boston.

The morning of January 10 was the occasion for a routine visit from Nevins. As head of the Pemberton's sales agency, his almost daily visits were for "attending to the styles of the goods," Howe said. It helped that Nevins lived only a few miles from the Pemberton factory, in Methuen. Howe seemed proud that both he and Nevins popped in frequently and without notice. "I made it a point, almost without an exception, to visit the mill once a week, and [to] go through every floor [with] Mr. Chase," Howe was to say. "I had the greatest reason to believe in his ability and faithfulness."

During his morning rounds on January 10, Nevins undoubtedly observed men moving machinery on the fourth floor. If the relocation was unusual, it might have been only because so many pieces of machinery were involved. Thomas Winn set the scene: "The first sixty feet from the south end was occupied in the center and the west division by forty card frames, weighing 1,000 or 1,200 pounds each. The next twenty or thirty feet [was occupied] by eight fly frames, weighing 3,000 to 3,500 pounds each—a total of between thirty and forty tons." An overseer, Edward P. Whitney, added, "I think we had much more weight in that part than in any other part of the mill. Where we set the fly-frames, a lot of cards [carding machines] were removed. I should think the fly-frames made a much greater weight to the square foot than the cards."

No one seemed to know exactly the weight of these carding machines. Chase estimated one ton each. Carpenter Benjamin Harding guessed "over 3,000 pounds apiece." Whitney's estimate was much greater: "I should think the [fly frame] machines weighed sixty-hundred pounds [each]." The *Boston Journal*, reporting Whitney's statement, added parenthetically, "The highest estimate previously was thirty-hundred."

All of this would be important as a way of determining if moving the heavy machines had weakened the mill's supporting units—the walls, the flooring and the pillars on the floor below. Captain Bigelow didn't think so. If the building's strength had not been

excessively challenged when the new machinery was put in position, relocating that machinery should not cause harm to the building, he reasoned.

Michael Hartegan, who worked on the third floor beneath the machinery, wasn't so sure. "I heard the sledging upstairs during the day. The mill was shaking all the time under the pounding," he said. "It made me nervous, and I wouldn't like to stand there."

The men who had wrestled with the giant metal machines were happy to see the hands of the clock advancing toward five in the afternoon. Whitney was resting, seated on a pulley. Perhaps he was mulling over what had taken place. He was to recall, "I made a remark that day that I didn't see what held the mill up. Nothing but the great weight caused me to say so."

After Nevins's morning visit, Howe said, Nevins had reported to him in Boston "that he had never been better satisfied with the operation of the mill than on that day." Howe took the 2:30 p.m. train out of Boston. As he walked into the offices in the Wing, he may have passed one of the young female operatives on her way out. A former resident of Johnston, Rhode Island, she had a "presentiment that something awful was about to happen," the *Providence Journal* reported. "She endeavored to dissipate the feeling, but was unable to do so. She went into the mill as usual but the matter pressed so heavily upon her mind that at about 3 o'clock p.m. she had to go home indisposed."

Knowing the workday was getting late, Howe said, "I went in company with Mr. Chase directly to the mill, as was my custom to do. We had passed through the Weaving Room and the principal Carding Room, the lower one." The Pemberton had been operating now for nearly two years under Howe and Nevins, so they could have made this building tour as many as a hundred times. Although not as outgoing as his partner, Howe is likely to have recognized some of the overseers along the way, and perhaps even nodded a greeting.

"From there," Howe continued, "we went to the third story Spinning Room. We entered at the north end, and as we passed the mules, I remarked to Mr. Chase that I thought that they were running remarkably well." But Howe spotted a pair of mules not working. The two men stopped—about fifteen seconds, Howe was to estimate—while Chase explained that the machines had been using "slacker twisted yarn, which broke them down."

Howe had never questioned the mill's endurance; he "judged of the building by its parentage. Messrs. Putnam and Lowell never have been known to slight anything for the sake of saving money. Money was of little consequence to them compared with stability."

Whitney, who had helped move machinery, did not have much time to ponder his efforts. Now, as he rested, the building began to shake. He was to recall, "We had not ceased moving the machines more than five minutes." As James Tatterson and Benjamin Adams discussed looms, standing on the lower floor in the south end of the Pemberton, they were, to use a modern term, near ground zero.

On the fourth floor, Rosanna Kenney was at her frame, drawing in. She heard a crash. A fallen beam of yarn, she thought. But then she heard a second explosion of sound and

she knew the mill was falling. Although only twenty-one years old, Rosanna was an old hand at the Pemberton. She had worked there since its opening six years before and she paid attention to details. She had heard earlier that some of the foundation stones had moved; indeed, only the day before, she said, she had noticed the building "rocking" and assumed that it was caused by a thawing and by foundation flaws.

Edmund Branch, whose job was in the Cloth Room, had stayed home that day with an injured finger. From his boardinghouse room across the canal at Pemberton 13, he heard the crashing sounds and for a time saw a group of overseers, covered with dust, as they fled the site. His father, Lafayette Branch, went missing for days.

George Howe thought "the noise sounded very much like snow sliding from the roof." N.P.H. Melvin, working in the Repair Shop, likened the startling sound and sight to "a rattling of particles against a window and the appearance of a cloud of dust."

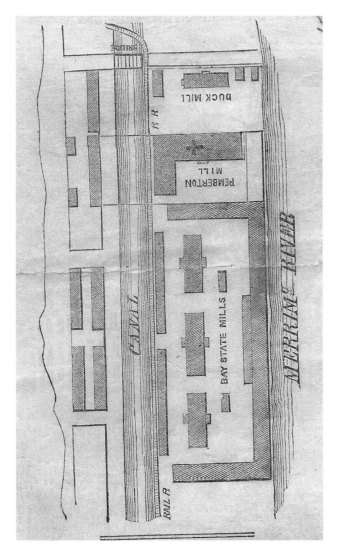

"X" marks the Pemberton Mill in a factory site drawing. Leslie's Illustrated Newspaper, *January 28, 1860. Courtesy of the Lawrence Public Library.*

The roar was heard beyond the Pemberton complex. Charles G. Merrill, a clerk in the post office on Appleton Street, was to recall: "I was…engaged in locking up the five o'clock mail for Boston and the first intimation I had of the circumstance was the clang of the City Hall bell."

Newspaperman Hayes wrote: "Immediately a wail went forth from all beholders, which, at a distance, was mistaken for a simultaneous cry of fire. The dust which rose upon the moist, still atmosphere from the fallen walls, filling it like a cloud, favored this delusion. The direction, to those at a distance, indicated that a terrible fire had broken out at either the Washington or Pemberton."

As big as it was, the main mill building fell fast. The exact time that the first brick wall fell was placed at thirteen minutes before 5:00 p.m. on Tuesday, January 10, 1860. Hundreds of survivors and witnesses knew the approximate time, but the pocket watch of Lafayette Branch provided what generally became the accepted hour of doom. When they found his body five days later, his timepiece—still in his watch pocket, its crystal facing broken—had stopped at forty-seven minutes past 4:00 p.m.

Today's television news brings pictures of huge buildings imploding when hundreds of explosive charges are set off simultaneously, just the way that the engineers planned. The Pemberton Manufacturing Company's main factory building went down in much the same way in a brief time—not much longer than it takes to read this paragraph. Storrow was to estimate the collapse took "a space of time not exceeding one minute." In sixty seconds or less, all six stories of the main building lay in ruins. In that blink of an eye in the late afternoon of January 10, 1860, the lives of several thousand people—employees, their relatives, a city and an industry—had been changed forever.

Even as the frightening sounds continued there came swift, furious movement everywhere in Lawrence. The *Courier*'s Hayes wrote: "Stepping into a sleigh, we were driven rapidly to the scene, but even before reaching a point where the extent of the disaster could be realized, it became painfully evident that something even more terrible than a fire had occurred. The deep-toned lamentations of the wounded and the friends of the operatives who had reached the point before us, were truly terrible to hear."

Dr. Lamb was among the first to see the stunning action at the Pemberton and he knew instantly that his professional help was needed. He recounted for a *Telegram* reporter years later: "I was standing in the doorway of the Lawrence Gas Company's office upstairs…when a peculiar and unusual rattling noise attracted my attention. Looking in the direction from whence the sound appeared to come, I was just in time to see the Pemberton Mill topple and fall, and immediately afterward there ascended from the debris a cloud of dust."

Other witnesses said the building's collapse began "near the center of the south end in the fourth story, and that the whole structure was pulled in by the weight of the machinery and the strong connection of the walls." The *Telegram* quoted onlookers as claiming that the entire structure seemed to "sway to and fro one more moment and then the immense pile of brick and iron fell upon its own foundation, and the shrieks of the injured rent the air."

Colonel Beal saw the disaster from a distance. He was painting at the top of the courthouse when he heard a noise and turned to see the Pemberton's north wall collapse. Some of the top floors crashed into the canal. Beal raced to the scene. A member of the City Hose Company, he was soon helping rescue mill workers, despite a nail wound in one hand.

Among those already below ground level was Damon Y. Horn, buried by twelve feet of demolition. An overseer in charge of the looms in the basement and first floor, he was able to dig "a passage to where he could be reached by those outside and saved."

For Harriet Brackett, terror suddenly halted a pleasant interlude as she stood at a window in the next-door Washington Mill. She had been making hand signals to Matthew Ryan in the nearby Pemberton as he playfully made a beard of cotton. Suddenly, she said, he jumped from the window. She described the Pemberton as "an inert mass [that] moved a little, paused a moment as if dreading to fulfill its horrible mission, then settled with a rather gradual, though tremendous, crushing force. From the scene of engulfed human beings there arose a shroud of dust which obscured the place for what seemed a space of several minutes." She was not to see Matt Ryan again immediately.

John Ward, in the fourth-floor Carding Room, confessed later: "I…was terrified. I stood nailed to the spot, and did not seem to have power to move, although I knew the building was coming down around me…When I came to…I was all covered over with blood from wounds in my face." Ward credited his position beneath a grinding stone with saving his life. After crawling beyond the ruins, he went to City Hall and found his wife, Elizabeth, who also worked in the Carding Room. Her injuries, like her husband's, were considered minor.

The paradox of meeting death or escaping unharmed was reported for a group of four people within a few feet of each other. Jane Brooks, only eleven years old, was badly injured. Her section hand in the Dressing Room, twenty-six-year-old John C. Dearborn, was killed. But Jane's mother and another child were unharmed. Mrs. Brooks was to recall that, "in some miraculous way," the girls found themselves on top of a zinc roof and slid to the ground unhurt.

In the Weaving Room, Ben Adams and the Tatterson brothers were among the few who survived. James Tatterson, despite a slightly bruised head, was able to free himself in about twenty minutes. He made his way the length of the building to the north end Weaving Room and found his brother coming from the ruins. John had ducked behind a wall protecting a gas meter. He said later, "I think about thirty of my hands are lost."

Agent Chase, conducting mill owner Howe on a routine tour, was credited with saving Howe's life. Dr. Lamb was to report: "When the column gave way, Mr. Chase [and] Howe were standing about twenty feet distant looking over the new machinery. Mindful of what might follow, the agent coolly took Mr. Howe by the arm and hastened to a door in the side of the mill which led to a room in the [Wing] office building above the counting room. A man of true gentility, he pushed open the door, then stepped back for Mr. Howe to enter first. Scarcely had his own foot crossed the threshold when, turning, he saw the mill prone upon the earth just beneath him." Chase apparently deigned the role of hero. He reportedly said, "I felt so faint I couldn't do much."

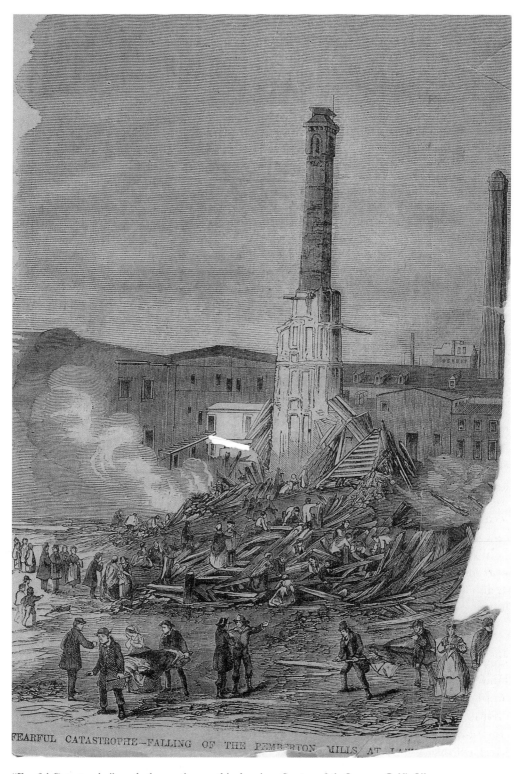

FEARFUL CATASTROPHE—FALLING OF THE PEMBERTON MILLS AT LA[...]

"Fearful Catastrophe" reads the caption on this drawing. *Courtesy of the Lawrence Public Library.*

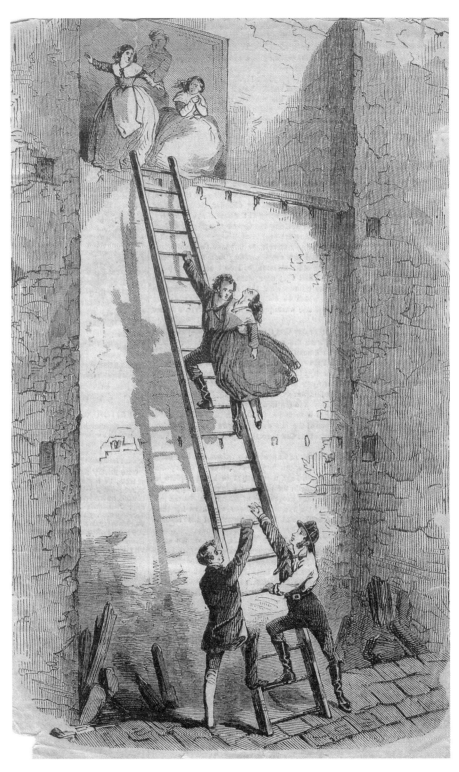

Firefighters guide to safety five women trapped in Pemberton's washroom, which withstood the building's collapse. *Courtesy of the Lawrence Public Library.*

The first minutes after the collapse brought a literally stunned crowd to the scene. They were not clear yet what had happened. They had only questions: Had a warning led to evacuation of the mill? Were the employees safely out of the way? "[D]oubt was soon dispelled," the *Telegram* reported. "Already the mangled form of a woman claimed the attention of the crowd…[She], in risking a desperate leap from one of the upper stories, was now picked up by kindly hands and carried away…Already, too, the loud cries for help, smothered only for a few moments after the first had been heard…were heard again, piteously praying for assistance and for delivery of those who were resting beneath the ruins."

Many who were rescued, a newspaper reported, "owed their escape from instant death to the arches of the looms, which resisted the immense weight of timbers and machinery, and left a space between the floors in which the sufferers could move about." James Tatterson, noting that not all of the first floor had collapsed, said he saw two little girls save themselves by jumping under the looms.

Tom Watson, who was headed for a trip to California, was physically beaten as his fifth-floor room collapsed. Injuries included fractures of three ribs and the lower jaw. His wife, Eliza, also a mill operative, had taken the day off—her first in six months—to get Tom's clothing cleaned and ready for packing.

The aptly named Anna Luck was standing beside her loom in the first-floor Weaving Room. When the building began to fall, she quickly jumped beneath the machine and called for Elizabeth Fish and Phoebe Barnes to follow her. None of them was injured. Anna's sister, Jane Luck, was buried for five hours but "was rescued without receiving so much as a scratch." A third sister escaped serious harm. However, two uncles of the sisters died, one killed in the collapse and another fatally injured.

Luck was on the side of many of the Pemberton's employees. A boy working on an upper level jumped into a waste box and rode safely into the tumbling ruins. Five lucky young women were in the restroom—called "the privy"—and escaped because that free-standing, narrow tower addition did not collapse for another twenty-four hours.

John Dean, a Pacific Mills employee whose firefighter duties were with Essex No. 1 unit, was with a small group working to free a half-dozen trapped women at 6:30 p.m. when he discovered one of them was his sister. Using scissors she possessed, she cut away enough of her clothing to escape. Dean later told the *Lawrence Telegram* about a survivor he encountered who was "busily engaged looking for his hat and coat. Mr. Dean said to him, 'For God's sake, don't worry about that, but get to work and help someone else.' But no, it was of no use; the young man wanted his wearing apparel, and that was all there was to it."

Some of the mill employees were unharmed despite dramatic escapes. Olive Bridges, who had come from Calais, Maine, left the fifth floor where she worked by grasping an elevator's hoisting chain and letting herself down. Selina F. Weeks, formerly of Dover, New Hampshire, had a rough elevator-like ride from the top-floor Spooling Room without a scratch. She was to express surprise that, after "recovering from the shock" of the fall, she realized she was still standing on the Spooling Room floor. Her experience

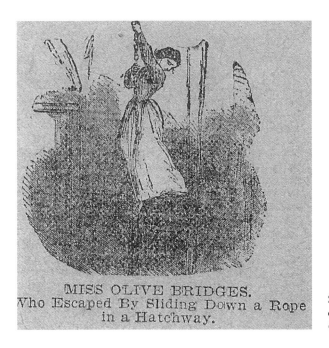

MISS OLIVE BRIDGES.
Who Escaped By Sliding Down a Rope
in a Hatchway.

Sliding to safety on an elevator shaft cable, Olive Bridges became a legend. *Courtesy of the Lawrence Public Library.*

was not unusual for this calamitous event. A reporter taking a broad survey concluded that "the floors seem to have descended without breaking apart."

Julia Hartigan had something similar to a modern elevator ride as the floors fell atop one another. She was near the south wall, in the center of the fifth-floor Spool Room. She remembered later: "The first thing I noticed the floor went down and [another girl and Julia] went with it. We seized hold of each other. When that floor went down to the next, we felt a short halt, and a sort of a shake, and so on through the floors."

Among those killed was young Margaret Hamilton. She never got to finish her first full day at work. A newspaper reporter quoted Mary Ann Hamilton, Margaret's mother: "Her arm is broken, and her head is broken, and, oh, my God, my poor darling is all broken."

Almost immediately, the less seriously injured occupants began pulling themselves from the piles of walls and timbers. Henry Nice was one of them. As he had stood in the Boiler House, a heavy article had fallen on his shoulders. To escape, Nice lunged forward against a door, which opened, propelling him onto a porch just as a falling brick wall buried him. Nice dug himself out and went to the main building to help in the rescue work. He was to learn that his brother Thomas's wife, Mary, who also worked at the Pemberton, had been killed.

N.P.H. Melvin, who worked in the Repair Shop, used his mechanical skills—and a huge amount of energy—to save two fellow employees. Leaving his undamaged building, just west of the main plant, Melvin peered through heavy dust clouds and saw two women crawling from the debris, covered with blood. "Do not help me," one of them told Melvin. "There are others in there." On hands and knees, Melvin crawled to a man wedged between two looms and a large shaft. Somehow, he located a monkey wrench and took one loom apart to free the trapped man. Picking his way through the

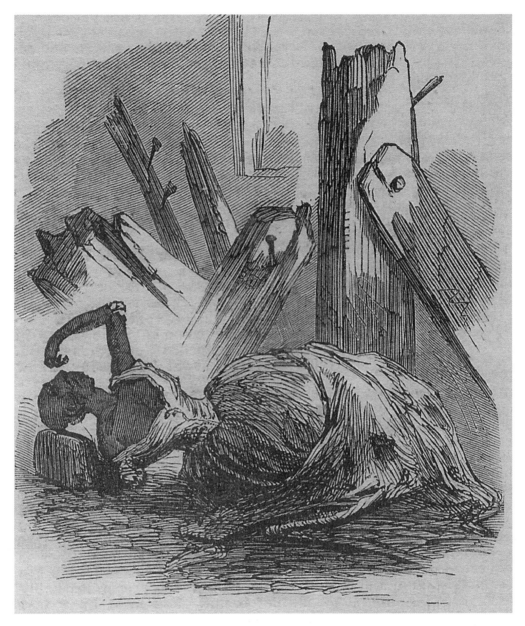

Sensationalism crept into artists' drawings such as this one, representing a corpse "immediately after it was taken from the ruins." Leslie's Illustrated Newspaper, *January 28, 1860. Courtesy of the Lawrence Public Library.*

jungle of debris, Melvin found a man pinned by heavy planks across his hips. The *New York Times* reported: "Mr. Melvin could not find an axe nearer than at his home, but ran thither quickly and on returning released the man by cutting the plank. He continued working in the ruins although suffering from an injured eye."

Rosanna Kenney was struck by falling harnesses and pinned beneath a rack. Her left arm and elbow were severely burned by a steam pipe and her right shoulder was injured, apparently by the tugging that rescuers used to extricate her body.

Watching helplessly from the Washington Mill building, Harriet Brackett remembered: "I saw several girls coming over the roof of the River Building of the Pemberton Mill and then leap to the ground in our yard…shrieking and crying with fright." As for Matthew Ryan, the leap from a fourth-floor window had caused severe injuries. Harriet Brackett, in recalling what she called "a harmless flirtation" with the twenty-year-old man, told of seeing him later: "Some men were passing with a litter and a man was upon it. It was Matthew. He saw [and] recognized me and spoke to me. 'Goodbye, Hattie. I'm done for,' were his last words, for he died after being carried into the City Hall."

James Reed, the overseer in the River Building, said, "I found my men jumping out of the back windows. One broke or dislocated his feet, jumping out on the rocks. I shut down the windows to stop the panic, and we afterwards got out of an end window."

Twenty-seven-year-old John Hughes, described as "a muscular man," was escaping from the Pemberton building when a falling wall slammed him. He was able to stagger eastward into the yard of the nearby Duck Mill before collapsing and dying.

Everybody in Lawrence, it seemed, stopped their normal activities and rushed to the accident scene. Shops and businesses closed. People at home hurried to the mills as the alarm spread. Daniel Saunders Jr., the city's mayor only nine days, was in the law office he shared with his new young partner, Edgar Jay Sherman. Sherman was to recall, "We heard a loud noise, like snow sliding from the roof of a building. In a few moments afterwards, Thomas Wright rushed into the office and said, 'The Pemberton Mills have fallen to the ground.' We hastened to the mills, a quarter of a mile away."

Over the next five hours and more, an estimated two thousand men and women formed search and rescue teams. Their task was to clear heavy machinery, huge timbers, large sections of brickwork and mountains of rubble. "This work," Hayes wrote, "was unremitting. All were anxious to do what they could to this end. But a lack of organization of effort rendered these labors less effective than they should have been. But the community was panic-stricken. The question seemed more what can *I* do than what is *best* to be done. It was a time when a calm and resolute leader, comprehending the magnitude of the calamity, and anticipating the time when exhausted nature must relinquish these efforts, might have inspired the suffering with renewed hope."

With the sound of the factory's collapse, volunteer call men rushed to fire substations maintained in several neighborhoods. Some of the younger volunteers were Lawrence High School students. A boy named Harrison was near the No. 2 engine house on Garden Street when he realized help was needed. He raced to his fire company's No. 3 engine house on Haverhill Street. The first one there, he opened the building and sounded the alarm. His assignment was to "run with the machine." In fact, he would be

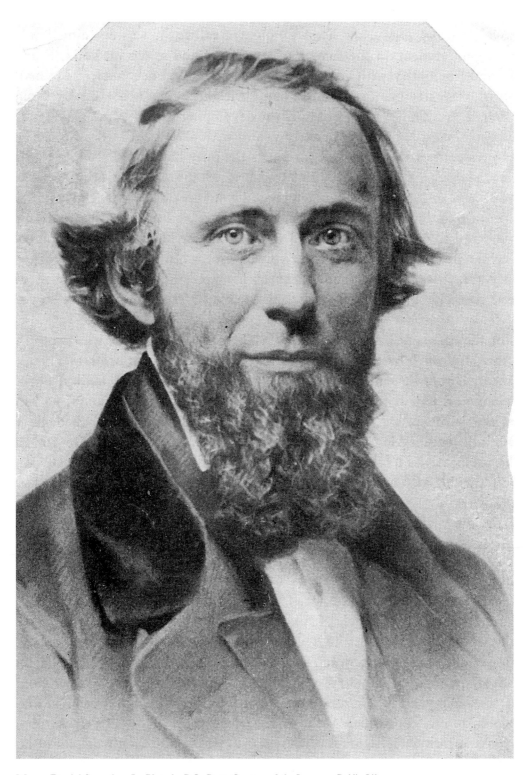

Mayor Daniel Saunders Jr. *Photo by D.L. Pratt. Courtesy of the Lawrence Public Library.*

helping to pull one of the city's four hand engines while running to the Pemberton site. Besides these "tubs," the six fire companies had a ladder truck and hose carts.

Charles Merrill had left the post office when he heard the City Hall bell and reported to his crew. "Rough and Ready No. 2 was, I think, the first company to respond," Merrill was to recall. "The others followed in quick succession, and all were there within twenty minutes after the fall." These companies pulled the tubs known as Essex No. 1, Syphon No. 3 and Tiger No. 4, all acquired within three years after the department's founding in 1847.

Harrison, running with Syphon No. 3, later wrote:

> *The fire alarm system as now used was then unknown, and all we had to guide us was the fact that the alarm came from the lower part of the town. When we reached the*

Common Street, Lawrence. *Courtesy of the Lawrence Public Library.*

Common, we took the path for the lower corner at Jackson and Common streets. While crossing the Common we began to meet men and boys hastening in the opposite direction, some not more than half dressed, some even barefoot, although there was a light snow on the ground…But we could get no coherent answer to our questions as to where it was. After leaving the Common, we proceeded down Jackson Street to Canal Street, and as we turned the corner…the terrible disaster burst upon our eyes. Of course, the engine was of no use to us then, and we left it there. Hands willing and ready to work were needed, and every man jumped with alacrity to assist in the rescue of those who were still waiting in the ruins.

Another account was given by G.A. Burredge, captain of Tiger No. 4. His fire crew pulled their hand engine by rope, running at top speed until they came to the North Canal. There, Burredge recalled later, the Pacific Corporation harnessed three horses and pulled the heavy engine along Canal Street until they came to the Atlantic Mill. Two new horses were joined and "the five set to and galloped to the Pemberton with might and main." The animals moved with such speed that only three men of the Tiger Company were with the engine when it reached the Pemberton—all of them seated atop the apparatus. One of them was Captain Burredge. The others, unable to run at the horses' speed, arrived out of breath but ready to work.

Mayor Saunders, meantime, had received permission to assign fire equipment to the nearby Duck Mill property. The Tiger's men hauled No. 4 into the yard and connected two hoses to hydrants, not knowing if water would be needed.

By 5:30 p.m., the Pemberton Mill lay in despairing blackness. Merrill said, "Fires were kindled contiguous to the place to afford light by which men could work." No. 4 company began its search and rescue efforts by battering a foundation wall to create a hole large enough for Captain Burredge to enter the basement area. Carrying a lantern and shouting as he searched, he saw a crouching girl, her clothing torn away. He guided her to the exit hole. Once outside, the captain wrapped his coat about the nude youngster and carried her to safety. In his account, the girl, "with great presence of mind, besought him to return to the sufferers in the ruins."

Burredge didn't have to look far for Edward P. Whitney, one of the men who had been moving textile machinery that day. Whitney remembered a "swaying" and then, it seemed, he looked up and saw Burredge approaching him in the Duck Mill yard. The captain said Whitney had suffered a head injury and had lost consciousness for perhaps a couple of hours.

Some of the stricken were helped in a relatively short time. Michael Rinn was one of them. A fifteen-year-old bobbin boy, he was one of fifty employees in the Blue House, the name used to identify the Weaving Shed. This one-story wooden building was crushed "like an egg shell," a newspaper reported, by bricks from the main mill's falling west wall. Michael had been pinned by a heavy beam for ninety minutes when he heard a familiar voice. John Morrissey was among the rescue parties that soon had Rinn and others safely removed. The boy had fractures of the collarbone and three ribs, and survived despite a physician's prediction that he would not live.

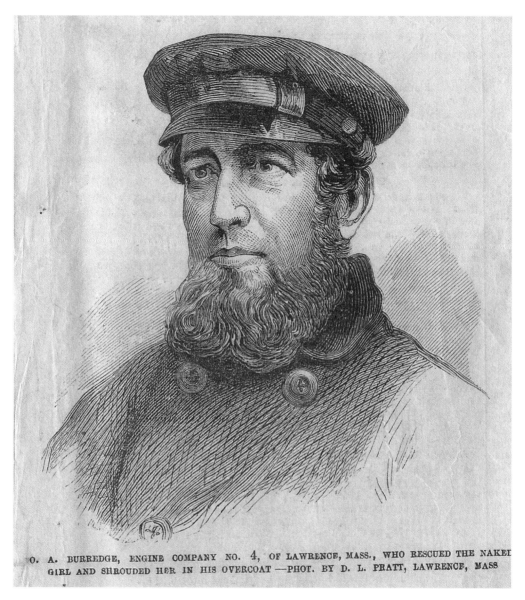

O. A. BURREDGE, ENGINE COMPANY NO. 4, OF LAWRENCE, MASS., WHO RESCUED THE NAKED GIRL AND SHROUDED HER IN HIS OVERCOAT —PHOT. BY D. L. PRATT, LAWRENCE, MASS

Captain G.A. Burredge of Engine Company 4, Lawrence, was credited with rescuing a trapped girl and using his jacket to cover her. In escaping, she lost much of her clothing. *Photo by D.L. Pratt. Courtesy of the Lawrence Public Library.*

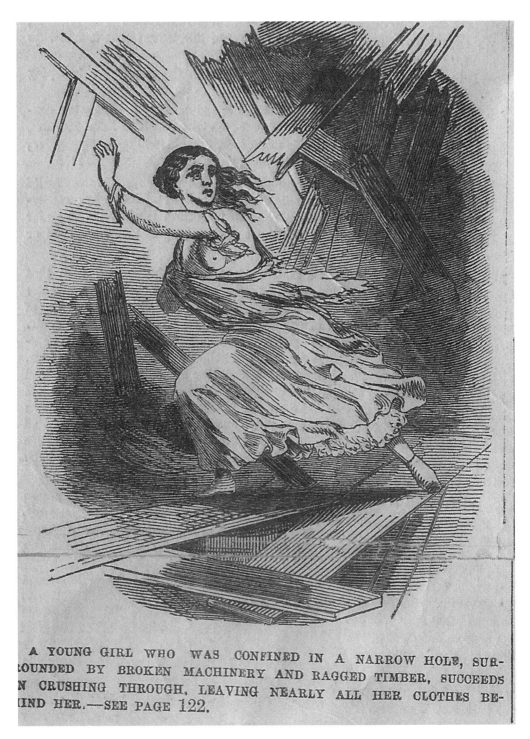

A YOUNG GIRL WHO WAS CONFINED IN A NARROW HOLE, SUR-
ROUNDED BY BROKEN MACHINERY AND RAGGED TIMBER, SUCCEEDS
IN CRUSHING THROUGH, LEAVING NEARLY ALL HER CLOTHES BE-
HIND HER.—SEE PAGE 122.

Leslie's Illustrated Newspaper drawing shows girl who lost her clothing while struggling through machinery and other ruins to gain freedom. *Courtesy of the Lawrence Public Library.*

For every tragedy, it seemed, there was a miracle. Here was the still body of a girl wedged under iron gearing weighing a half-ton. Four men tugged at the metal carefully and without success. But then an athletic man passing by reached down and with super strength loosened the gearing. Carefully removing several pieces one at a time, so as not to send another metal load crashing onto her body, the rescue team was able to take away enough of the rubbish so the girl could be hauled to safety. To their surprise, she was only slightly injured.

A similar case took place nearby. Relatives and friends pulled away bricks and iron piled tightly on a woman's body. Her husband carried her to their home, where more friends and kin joined the grieving group. The crying stopped when suddenly an arm of the "corpse" shot up and the woman shouted, "I'm safe! I'm safe!"

Following the sound of screams into what had been the Spinning Room, Henry Nice came across Lizzie Flint and Darius Nash. For several hours, they had been pinned in awkward positions. Nash's head was in Flint's lap, and one of his shoulders, itself under a heavy metal counter shaft, was crushing one of her legs. Charles Storrow reported: "'Save Nash first,' was the cry of Lizzie Flint…Poor Nash, whose brother lost his life, was indeed saved."

Early on, City Hall rooms were turned into a temporary hospital and "dead-house." From the mill came the unrecognized dead, carried on biers, and the severely injured, brought on makeshift litters. Newspaper drawings at the time showed two and four people carrying a sheet with its heavy load sagging, lifeless.

A reporter saw this scene: "Each [team of bearers] was followed and surrounded by a crowd of excited persons, ministering to the comfort of those not already dead, or filling the air with cries as they saw the death stamp fixed unmistakably on the features of friends and relatives."

At first, one corner of the great room at City Hall was designated "the Dead Room." One report described the scene: "This was literally covered with mangled corpses. Men and woman, old and young, lay there, a ghastly sight to behold."

The *New York Times* reported at 11:00 a.m. on Wednesday that nineteen "wounded are now at the hall" and "twenty-two corpses, only the following of which have been recognized: Mary McDonald, John Dearborn, Bridget Ryan, Margaret Sullivan, Mike O'Brien, and Mrs. Palmer."

Fifty or more physicians, including every Lawrence medical doctor, were on the scene quickly. Most remained a few days. Answering the call for help were twenty-two physicians from Lowell, ten from Haverhill, six from Manchester, New Hampshire, and two each from Bradford and Methuen. Also assisting were two physicians who happened to be passing through from Derry, New Hampshire, and Brooklyn, New York.

Many women from the community arrived to tend the wounded and dying. Among them was Olive Bridges, who had escaped on the elevator cable. She remained on duty at City Hall all night, "passing like an angel of mercy among the couches of the sufferers, anticipating every want, relieving pain, and breathing words of comfort and consolation to the wounded and dying," according to one reporter.

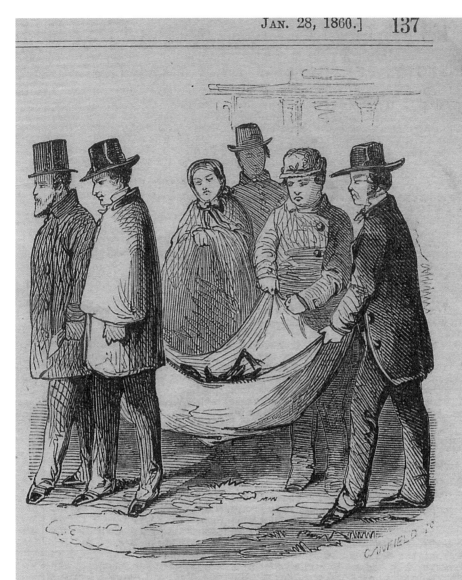

BRINGING THE BODIES OF THE DEAD OR WOUNDED TO THE CITY HALL IN A SHEET.

Suspension of Work in the Duck Mill.—The Boston *Journal* of the 16th inst. says operations have been entirely suspended in the Duck Mill since the calamity, none of the late operatives being found willing to risk their lives in the building. The apprehension for its security is greatly increased by the falling of a portion of the coving on the southern end of the mill. This accident happened about a month ago, and resulted in the demolition of the coving on one-half of the roof from the eaves to the ridge-pole. This was probably occasioned by the location of heavy duck looms in the fourth story, the operation of which produced greater jarring than exists in mills generally.

Bodies were carried in sheets to the City Hall morgue. Leslie's Illustrated Newspaper, *January 28, 1860.* *Courtesy of the Lawrence Public Library.*

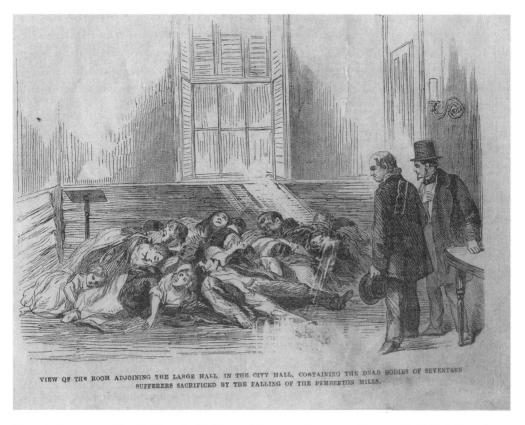

VIEW OF THE ROOM ADJOINING THE LARGE HALL, IN THE CITY HALL, CONTAINING THE DEAD BODIES OF SEVENTEEN SUFFERERS SACRIFICED BY THE FALLING OF THE PEMBERTON MILLS.

Mound of corpses at City Hall in a *Leslie's Illustrated Newspaper* drawing on January 28, 1860, belies other periodicals' descriptions of neat rows. *Courtesy of the Lawrence Public Library.*

One reporter wrote: "With the arrival of each body, the surging crowd divided to let it through. A police officer was stationed to guard the door to the temporary hospital in the main hall. The platform at one end became the dispensary. Settees were piled along the walls to clear the floor. Donated mattresses, blankets, and sheets were placed in rows along three walls, and the wounded were placed on them." Other local gifts arrived from druggists and nearby homeowners. They included bandages, cordials and medicines. Within hours, donated articles were coming also from all over the region. The owners of the steamer *Menemon Sanford* sent 125 sheets and a supply of lint.

Hayes's history described the scene: "Few persons, except the physicians and nurses, were admitted to the hall, but a dense throng filled the street, the steps, the lower floor, and the stairway; a body of police guarding the door to prevent the crowd from entering the hall. The sight inside baffles all effort at description. The imagination is better fitted than the pen to picture the mental and physical suffering, the moaning and cries of wounded and dying, and the anguish of relations at the suffering or death of those they loved."

The *Lawrence Telegram* also described the scene: "Stretched on pallets in the large room of the upper story of the City Hall lay those mangled, bleeding forms, a few hours since full of life and hope, now momentarily expecting to find relief from their torture in

Olive Bridges escaped through an elevator shaft and went to City Hall to help the injured. Leslie's Illustrated Newspaper, *January 28, 1860. Courtesy of the Lawrence Public Library.*

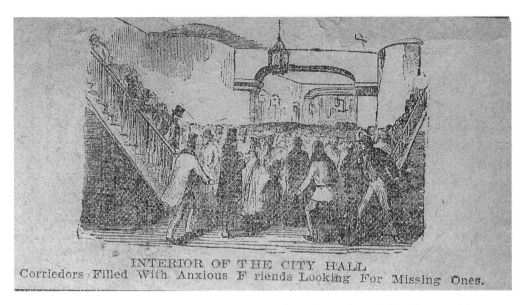

INTERIOR OF THE CITY HALL
Corriedors Filled With Anxious Friends Looking For Missing Ones.

City Hall corridor, with the morgue in a nearby room, is filled with anxious relatives. *Courtesy of the Lawrence Public Library.*

death. Here again were parents, relatives, and friends, bending over their beloved ones, and mingling their sighs with the groans which excruciating pain drew forth."

Young Harrison, who ran with the Syphon engine, retained a detailed memory of the temporary hospital: "Nearly the whole of the main floor of the hall was covered with those who had been brought there. Injured many of them past recognition, it was a sight not easily to be forgotten. Although some years later I had some experience upon the [Civil War] battlefields, I never saw anything there to equal this."

The first news report from the Associated Press went out at 6:00 p.m., little more than an hour after the collapse: "[S]ome two hundred or three hundred are still supposed to be buried in the ruins." The AP, whose wire service reports went to hundreds of newspapers around the country, also sent dispatches at midnight on Tuesday ("The screams and moans of the poor, buried, burning, and suffocating creatures can be distinctly heard") and at 1:30 a.m. on Wednesday ("Probably not less than two hundred human beings perished in the flames!").

The *New York Times*'s first dispatch, like the AP's, tended to sensationalism: "The mangled bodies are being taken out by the cartload. It is supposed that over two hundred were killed instantly." Sticking with the estimate of dead, the *Times*'s 9:00 p.m. dispatch continued somewhat breathlessly: "Eighteen dead bodies have been already taken out, together with some twenty-five persons mortally wounded, besides some fifty in different stages of mutilation…Huge bonfires are burning to light some two or three thousand persons who are working as if for their own lives to rescue the unfortunate persons, many of whom are still crying and begging to be released from their tortures."

Among the first Boston newspaper reporters at the scene were Samuel W. Mason and E.B. Haskell, representing the *Journal*. They did not board the train to Reading,

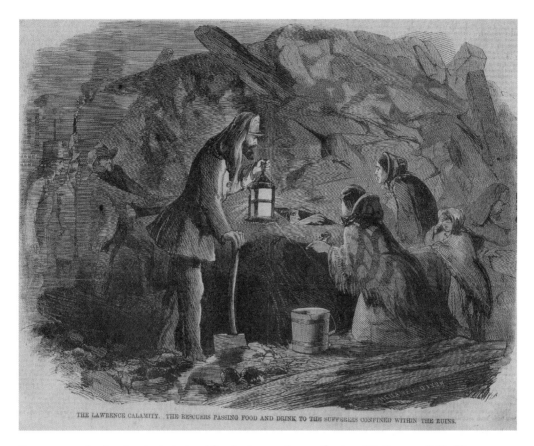

Rescuers pass food and water to trapped Pemberton employees. *Courtesy of the Lawrence Public Library.*

the nearest station stop, until 9:00 p.m. on Tuesday. From there, they took a horse team to Lawrence, arriving at 1:00 a.m. Echoing the *Courier*'s Hayes, who had arrived six or seven hours earlier, they wrote of their trip to Lawrence: "Approaching within five or six miles of the city, between 12 and 1 o'clock, people were found riding and walking to or from the scene of disaster. Every house was lighted up, and knots of people stood by the roadside, eagerly listening to the latest news."

While the journalists were coming to Lawrence from Boston, more than twenty bodies had been pulled from the huge wreckage and dozens of the injured had been bandaged and sent home. Five hours after the crash, more than sixty people who had been working at the Pemberton Mill remained trapped. City Missionary George P. Wilson wrote later, "Coffee and wine were lowered to some who could not be liberated." Crews of volunteers were still struggling to shift tons of machinery and building materials in order to free the screaming and moaning factory hands from their confinement. As stunning as the news had been during the evening hours, much worse was coming. The number of dead people, and the loss of property, was to multiply.

FIRE!!!

As the efforts are progressing, hope despondent rises higher; for some yet remain uninjured – but, OH GOD! The cry of FIRE! Now, alas! No power can save them! Hearts that fondly hoped awhile, yielding to despair, now perish; perish on one funeral pile!
—*a ballad by Jim Douglas*

Nearly six hours after the Pemberton's collapse, hundreds of people were making progress slowly, bringing out a body here, and soon an injured person there covered with soot and blood.

Already something of a miracle had occurred: not a single one of the hundreds of gas lamps that had been lighted when dusk was darkening the work areas had caused a fire. "The gas was undoubtedly extinguished," a writer for the *Journal of the Franklin Institute* was to decide, "before a single burner, out of the hundreds that were lighted, came in contact with any cotton…No fire originated from the gas lights…It is supposed a draught of air through the pipes extinguished all lights, or that pipe-connection was broken at the outset."

Historian Rollins claims that whale oil was being used in the lanterns: "[I]t should be stated, as it has not been, that at the thoughtful suggestion of the mayor (Mr. Saunders), the kerosene lanterns in use on the ruins had all been carried off and exchanged for sperm-oil lanterns, as less liable to cause accident."

Sixty or more men, women and children—most of them conscious and pleading for help—lay trapped in the mill's debris. Volunteers crawling over the wreckage were being alerted to the danger of fire. John Pindar, who worked at the Washington Mills, told of his warning: "Said I, 'For God's sake, look out for fire with your lanterns.'"

It may have been impossible to avoid an accident in such a mountain of flammable materials. As recorded by newspapers, six or eight men, trapped in rubble in the building's east end, called for a lantern to help them find an escape path. A lantern, being lowered through stacked wooden beams and machinery, fell "onto the floor of the pit," according to *Harper's Weekly*.

"Calamity succeeds calamity!" the *New York Times* reported in a midnight dispatch. Most observers agreed that a lamp's flickering flame spread in a few seconds to the nearest scraps of raw material. Probably within a minute, a wall of fire raced through

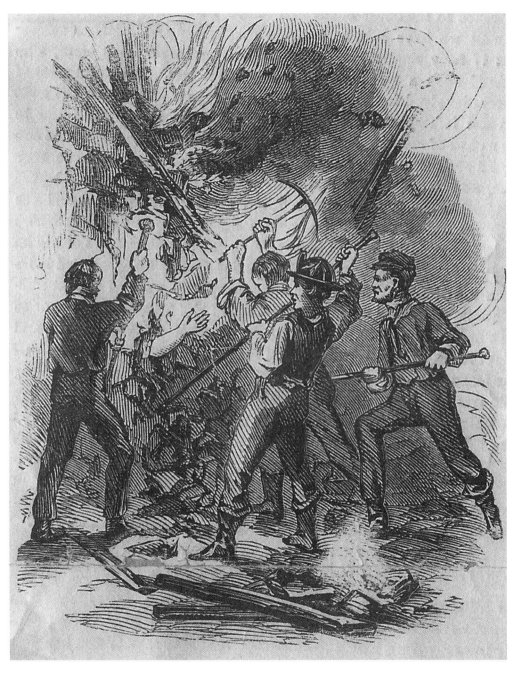

Some were burned alive as flames outraced rescuers. Men were unable to enlarge a hole for this girl, shown waving an arm from the opening. *Courtesy of the Lawrence Public Library.*

tons of dry cotton and waste saturated with oil. Soon also ignited were the tons of wood used in the mill's construction. Besides huge timbers that burned for hours, even days, there was wood flooring made combustible by oil drippings from machinery.

John Crawford, a former Pemberton employee, had left his new job at the Washington Mills to search for his daughter, a Pemberton employee. He told of the fire's start: "I was on the ruins when a young man came up and asked me to hold a lantern. I held it for almost ten minutes, when somebody asked for it, took it, and went down [into the rubble]. He came back and said there was a deep hole there which went down to the Card Room. He went down again…and in getting down struck the lantern on some timbers on the right hand side. When he struck the lantern, it broke and immediately fell. I shouted 'Fire!' and stooped down to pull him out. He was on fire himself, and the fire was spreading like gun-powder."

Richard H. Plumer added to Crawford's story. "I went towards the center of the building to cut a hole," he said. He described the location as about a hundred feet from the south end of the mill, a little east of center. "We cut a hole in the roofing about ten feet by three feet," he continued. "We found some dead bodies there, and there were some persons endeavoring to get out another body. Two persons were holding lanterns for these men. One of the lanterns dropped [and] fire sprung up from some loose cotton. I called for water, but found none; took off my coat to cover the fire and smother it, but it had got so large that I could not."

Storrow reported "a thrill of horror ran through the stoutest heart as the thousands working with almost superhuman effort for the rescue of the unfortunate victims were successively driven off by the flames and forced to abandon friends, relatives, and neighbors to their awful fate."

Frederick Clarke, the paymaster, rushed to the Wing. He had been helping with rescue efforts in the main building, but now fire threatened the company's vital office records. He said, "I had locked up the safe. I returned and found that it was too late to save the [payroll] list." The only accurate list was lost as flames swept through the Counting Room. And, said Clarke, there was "no perfect list of the hands employed. It was left out of the safe, as the clerk was using it at the time. There is no way of knowing how much is due to each of the hands, excepting that due-bills were given to all the hands excepting in the Weaving Room up to the last Saturday in December."

Maddeningly, rescuers could see the trapped Pemberton employees but not reach them. One success was recorded with Ben Adams. Frantic as flames closed in, he was able to free himself using a saw and an axe that were eased through crevices created by the tilted ruins. A man who had found two young women trapped but comparatively comfortable reached coffee in to them with the assurance that they would be rescued "in fifteen minutes." As steady as the clock's moving hands, fire spread toward them. Despite doubled efforts, the volunteers were forced to flee as flames ended the women's lives. Ironically, safe crawl spaces such as the women's, which had been formed by tilted flooring and machinery, had become flues, drawing flames and heat with frightening speed.

Here was the biggest fire in the city's short history and it is likely that the fire alarm was not sounded. There was no need. Charles Merrill recounted the fire crews' efforts

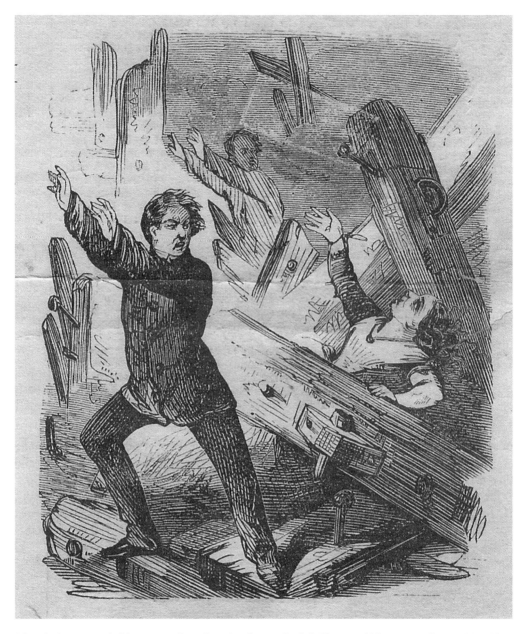

Abandoning trapped girl, rescuers flee advancing flames. Leslie's Illustrated Newspaper, *January 28, 1860.*
Courtesy of the Lawrence Public Library.

under Chief Luther Ladd: "The cry of 'Fire' caused every fighter to jump to his place by the machine and the 'brakes' were valiantly manned and streams from the nozzles coolly directed. The efforts of all firemen and rescuers alike were redoubled and nerves were strained to the greatest tension."

The water works connected to the mill were rendered useless by the destruction, according to one account. Still, much water was poured on the burning mill from various sources. Eleven streams came from hydrants at the Washington Mill. Also in use were some of the city's seventeen hydrants and water reservoir on Prospect Hill. The Rough and Ready Company's Merrill wrote: "The position of the wreckage was such that the efforts of the firemen oft-times counted for but little. The floors in falling made such an angle or pitch that the water was shed as from a pitched roof, making it impossible to reach the heart of the fire."

Captain Burredge and the men of Tiger Company were to use, for the next twenty-four hours, the two hoses they had connected at the Duck Mill. Hayes estimated "fifteen or twenty streams, enough to deluge any building in the city, were poured upon it in a vain hope of checking the flames." Hayes reported smoke moving from the south end of the Pemberton "slowly at first, but yet surely, in spite of every effort of the firemen to check it…In about an hour, the devouring element had made its way a little north of the center of the mill, from which point its progress was rapid."

Story after story was told of rescuers following the cries of trapped workers. A fire department engineer told of his crew's finding of two men and a woman caught behind a crumbled partition. He had clasped one of the men by the hand, hoping to pull him to freedom, when flames forced him to leave. The engineer had been able to glimpse the imprisoned people, and none appeared to have been injured, he said. The news report concluded: "And they must have literally roasted alive."

That was the fate of young Lizzie Flint. Trapped in the Cutting Room, where she worked, she had watched through her pain as a rescue team removed Darius Nash, pinned down next to her. That crew moved on to others screaming nearby and had not returned to Lizzie before flames swept over the accidental prison that had trapped her. Storrow commented philosophically: "The poor girl did not survive. Who shall say that she was not saved also?"

A similar case involved Mayor Saunders. He had pitched in with hundreds of other men as flames devoured the mountain of rubble. He was to remember:

> *One terrible case came under my personal observation. A little girl about fifteen years of age, who supported her younger orphan brothers and sisters, was buried in the ruins, but not injured. We had nearly extricated her; ten minutes more and she would have been safe—but the flames came. You must imagine the rest. I can't write it. Oh! how fervently our prayers joined with hers to God. There are many very sad cases. I can't write—it unmans me.*

Perhaps Saunders associated the young victim with his own family. He and his wife, Mary Jane, had a ten-year-old daughter, Mary Livermore Saunders.

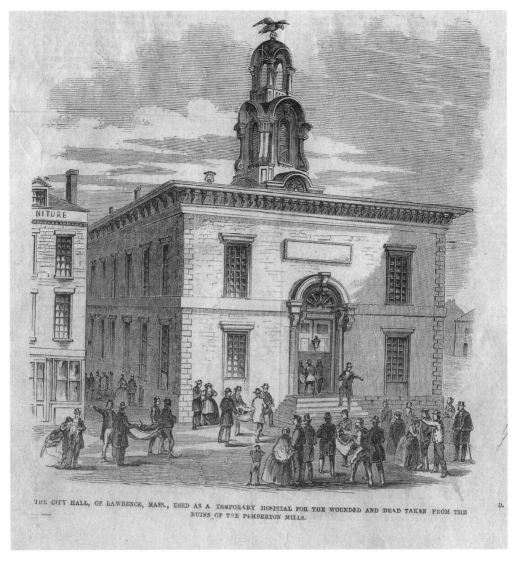

THE CITY HALL, OF LAWRENCE, MASS., USED AS A TEMPORARY HOSPITAL FOR THE WOUNDED AND DEAD TAKEN FROM THE RUINS OF THE PEMBERTON MILLS.

Victims are carried to City Hall morgue and temporary hospital. Leslie's Illustrated Newspaper, *January 28, 1860. Courtesy of the Lawrence Public Library.*

Fear was to overcome Maurice C. Palmer. A native of Maine who had come from Rochester, New Hampshire, the thirty-five-year-old father of three despaired as friends desperately moved debris in order to free him. As the heat of the nearing flames reached that area, Palmer freed one hand, drew a knife and said he would commit suicide rather than burn to death. When he had given up hope, he drew the knife blade across his throat. Soon, however, the rescuers were able to free his body. At the City Hall "hospital," William H. Burley, a Lawrence physician, reported the irony of Palmer's death. He said, "I thought if he had had no other injuries than those wounds in his neck he might have lived. I think his internal injuries were severe enough to make his living impossible."

Courage marked the death of James Bannon's twelve-year-old daughter. Mary Ann was trapped with at least one other youngster. As flames neared, she reportedly handed her pay bill—the accounting needed to collect her wages—to another girl and said, "You will be saved; I shall not. Give this to my poor father and bid him goodbye for me." Storrow added: "The [other] girl escaped, and the partly burnt paper was given to the father. Mary Ann was never seen again."

As this terrible Tuesday became Wednesday, a Boston daily newspaper reported:

> *At midnight, messengers drove about the city calling upon the inhabitants to bring out lanterns to light up the scene of the disaster, linen to be used for bandages for the wounded, and other necessary articles, which were quickly forthcoming. As fast as the wounded were rescued, they were conveyed to their boarding houses in different parts of the city; and when the physicians from abroad began to arrive, messengers were again dispatched from house to house announcing that medical aid could be had by sending to the City Hall.*

The *Boston Journal* recorded a new collapsing wall at midnight. This was the west wall of the main mill, the northerly half that ran from the privy tower to join with the Wing jutting to the west. This is probably the wall that carried tons of bricks onto the Blue House and the freight cars on the railroad siding nearest to the Washington Mills. The privy tower remained standing until late that Wednesday. The force of the falling wall was so strong, according to the *Boston Daily Evening Traveller*, it crushed several rail cars that had brought cotton to the mill. In a short time, they too caught fire and were destroyed.

Rescuers were on the collapsed Blue House within minutes. Credited with saving the lives of Bridget Bradley and Margaret Hayden were Joseph Howard and Gustavus V. Fox. Howard had come to Lawrence to help his eighteen-year-old cousin, Augusta Ann Ashworth, whose body would be found later. Fox, one of the Washington Mills' first resident agents, was not a large man (Benjamin Butler described him as standing only "five feet nothing"). He was also credited with saving girls who were uninjured but trapped in the basement near the Pemberton's south wall. Fox and an unidentified man followed the children's cries for help, beating back flames as they got closer. Using a saw and working in the heat of flames, they cut an opening. It's probable the man working with Fox was Enoch Bradshaw, a member of Lawrence's Engine Co. No. 1. "An Eye Witness" wrote in a letter published by the *Lawrence Sentinel*: "[I]n conjunction with the noble-hearted Capt. Fox, [he] performed astonishing feats of bravery and strengths. His efforts were eminently successful, some six or seven being rescued."

By 12:30 a.m., fifty-four wounded workers were on mattresses in the City Hall hospital. Wrote an observer: "Everywhere was blood, bruises, and broken limbs. Nearly every one of the wounded here had a leg or an arm broken." Around almost every patient grouped "a little circle of weeping ones." A half-dozen friends were with a young woman who had a skull fracture and severe internal injuries. One of the many area physicians at the scene warned that her death was near and even as the friends prayed that "her misery might be shortened," she died. Near each other across the room were

three dying girls. Another youngster succumbed in the arms of her father. Not all of the wounded had consoling friends, but "young women and matrons, like ministering angels, hovered around them, cheered them with hopeful words, and assisted the labors of the physicians with gentleness and skill."

Among the injured was Hannah Fennessey, a thirteen-year-old girl whose main wound was a fractured femur. Hannah was doffing in the Spinning Room when the floor went out from under her. She told of being trapped for hours with a group of men—she described them as "Americans"—who were working to find a way to safety. As flames advanced toward them late that evening, six of them yielded to the heat, but three others kept moving debris until they had freed her.

Volunteers carried Hannah, with a broken leg and maimed hand and arm, to City Hall, and it was there that her unhurt nineteen-year-old brother was to find her. He had run to a Weaving Room window as the building collapsed, taking him with it. He had been able to clear the bricks and mortar that buried him. But he was not to escape injury. Running from the burning building, Fennessey tumbled into the freezing water of the canal.

The "last one rescued alive," according to newspaper accounts, was Ira D. Locke, a Weaving Room employee from Deering, New Hampshire. More than seven hours after the mill collapsed, fierce flames scorching him, Locke urged rescuers to save themselves. But they worked on and removed him—critically burned but alive.

Mary Crosby was rescued about the same hour. She put the time at 12:30 a.m. One of three cousins here from England, she had been in the Drawing-In Room. Mary was brought out with only minor injuries but she lost two close relatives. They were a sister, identified as Eliza in one newspaper account, and their eleven-year-old cousin, Ellen ("Nellie") Conners. (The list of the dead does not have an Eliza Crosby. Among the dead were Irene Crosby, age twenty-one, and Bridget Crosby, nineteen.)

After midnight, a *Boston Journal* reporter said that while still miles from "the scene of disaster…a bright light was seen reflected in the sky." That was the spectacle he had come to record. When the journalist arrived in Lawrence, "the appearances of excitement increased…The whole community seemed to be abroad, and a wild throng gathered about the ruins, which were still fiercely burning."

At 1:30 a.m., the Associated Press sent its latest report: "The Pemberton Mills are now a flat, smoking mass."

Often in darkness, volunteers continued nightlong rescue efforts in parts of the factory complex not touched by fire. Leadership came from official sources—notably the fire and police officers—but as well from many men, and a few women, who had gone to the scene as spectators and stayed to work. "Conspicuous among the rescuers who directed excited masses," reported the *Telegram*, were Mayor Saunders, Henry Oliver, Agent William C. Chapin of Pacific Mills, Fox, Postmaster Benjamin F. Watson, City Marshal John S. Porter, Captain Samuel Langmaid, John R. Rollins, James T. Boardman, Samuel Webb, Chief Ladd and Captain Burredge of the fire department, Reverend Henry H. Hartwell, Joseph Norris, William R. Spalding, Moses Perkins, Albert R. Brewster, John C. Hoadley, Harrison D. Clement, Stephen P. Simmons and City Missionary George P. Wilson.

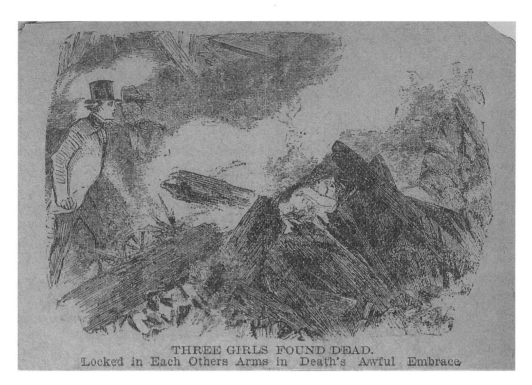

THREE GIRLS FOUND DEAD.
Locked in Each Others Arms in Death's Awful Embrace.

"Three girls found dead, locked in each other's arms," read the caption. Leslie's Illustrated Newspaper, *January 21, 1860. Courtesy of the Lawrence Public Library.*

Men were not alone in facing danger. A woman who literally leaped to help was credited with inspiring volunteers who had been hanging back in fear for their own safety. A rope had been tied to a timber that would have to be raised to rescue mill hands trapped in the rubble. When a group of men stood by warily—if the tied timber were to fall, even more damage was likely—the unidentified woman "rushed from among the crowd and, daring the spectators to follow, seized the rope and attempted to mount the pile of smoldering ruins, to clear away with her hands," a newspaper reported. "The example was enough; not a word was said, but strong hands at once drew the female back, and then there was no lack of hands to the rope." At least two people were released then.

At one point that first night, an exhausted fire crew called for new help and it came quickly from a group of women who had been watching from a Canal Street sidewalk. Harriet Brackett related the incident in a *Telegram* interview:

> [W]*hen the men working the fire machines became exhausted, volunteers were called for. The bystanders did not respond quite readily and so Carrie Mason, not [overly] strong, came forth and said, 'Let me help,' and she did so, and I went with her. We laughed in spite of the surroundings. We were both girls, and the big handles worked down on our side, and when they came back we went with them. That would lift us off the ground with a funny sensation and must have been a ludicrous sight.*

The Lawrence Fire Department had help from neighboring communities. The *Telegram* reported that nearby Andover sent "the 'Speeder,' a light hand engine also of the 'tub' variety." From North Andover came the "'Merrimack No. 1' and the 'Cochichewick No. 2.'" Lowell, Haverhill and Bradford crews also responded. Arriving at mid-morning Wednesday, from Manchester, New Hampshire, was a steam fire engine. Reported the awed Charles Merrill: "This machine was a wonderful revelation to our department, and its operation and the method employed in subduing fire…was, compared to our service, a conquering hero." Throughout the night, firefighting teams encouraged each other to continued energy by singing "revival melodies and old-fashioned psalms."

The Lawrence Police Department had all its officers on duty and welcomed volunteers from other communities. Fifty Boston policemen, sworn in at Lawrence City Hall that Tuesday night as special officers, were soon assigned to crowd control. Even then, the curious were breaking safety lines to get at souvenirs.

Community women performed the more traditional service of feeding firefighters. Syphon Engine Company No. 5's foreman, Thomas Stratton, sent thanks to "the ladies, though strangers to us, who furnished refreshments at intervals during the night." Engine 5's men also lauded "Mr. and Mrs. Burbank" who "provided and superintended the breakfast for our company on the following morning."

The clergy of Lawrence worked from the beginning, helping clear debris at the fallen factory and working on fire equipment to relieve the firefighters. All week they prayed, privately and publicly. They encouraged survivors and families, conducted funerals and burial services and preached Sunday homilies aimed at bringing consolation to the thousands in their churches.

The night of horror and heroism was ending now, leaving broken lives in the terrible piles of rubble that had been the Pemberton Manufacturing Company. As the new day dawned, many of the volunteers were going home to rest, or to check more closely on the safety of friends and relatives. Weary from their long duty, firefighters found the energy to drag equipment and apparatus back to the stations.

Newspapers were passing along the best available reports. The *New York Times* on January 11, for example, relayed exaggerated information in a series of headlines over a story. The display shouted "two hundred killed, one hundred fifty wounded, probably a hundred persons burned to death." Beneath the headlines were stacked four dispatches, in chronological order, beginning at 6:00 p.m. on Tuesday. On a page with editors' opinions, the *Times* called this "one of the most terrible catastrophes on record."

The next day, January 12, the *Times* had revised the number "killed outright" to 115, a figure given by Mayor Saunders. Three full columns followed with details, including the names of eighty-three persons dead and missing, seventy-four "wounded" and a list of insurance companies that had issued policies totaling $115,000 "against fire only."

Harper's Weekly virtually filled a front page on Wednesday with a drawing of the Pemberton ruins. The drawing showed a single stream of water being poured into black, tangled mounds of beams and bricks. Tall chimneys stand stark against a sky made dark by furious smoke clouds rising from the haunting scene.

THE CALAMITY AT LAWRENCE.

WORK ON THE RUINS.

EIGHTEEN MORE BODIES RECOVERED.

SERVICES IN THE CHURCHES YESTERDAY.

A DAY OF MOURNING AND PRAYER APPOINTED BY THE MAYOR.

THRILLING INCIDENTS

BURIAL OF THE DEAD.

Condition of the Wounded.

RELIEF FOR THE SUFFERERS.

Special Dispatches to the Boston Journal.

Headline gives news briefing. *The Boston Journal. Courtesy of the Lawrence Public Library.*

An Associated Press story offered an assessment of the working press that may sound familiar to modern purveyors of "breaking news" as provided by television stations. Noting a "strong force of reporters," the AP said the "voluminous" accounts "really afford little to add to the many facts already given."

But opinion was everywhere—often within a news report, occasionally in a separate piece randomly placed among otherwise objective stories. The irony of the Pemberton's fallen walls, and the fire escapes with them, was noted. A *Boston Herald* writer began a three-hundred-word reflection under the headline "Fire Escapes": "Among the precautions taken by the original proprietors of the Pemberton Mills to ensure safety of

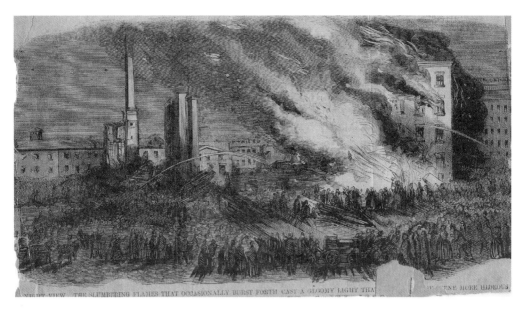

Rescuers clamber over ruins, the morning after the fire, seeking victims, dead or alive. *Courtesy of the Lawrence Public Library.*

life to the operatives was a number of fire escapes, which would enable them to descend safely to the ground upon the outside of the building. This escape was, alas! Of no avail in the fire that broke out after the building fell." The writer goes on to consider a "very sensible" suggestion from a mason—rooftop escape paths for contiguous buildings in cities. He concluded that the idea "is, certainly, worthy of consideration."

The nation's attention clearly had been brought upon Lawrence. The newspapers seemed to be competing not simply to be first with the most news but also to attain the maximum disaster rating. It would have been hard to top *Harper's Weekly*. In an issue nearly two weeks after the mill's collapse, the illustrated New York paper headlined "The Slaughter at Lawrence" and asserted: "The catastrophe which destroyed this mill is almost unparalleled in our history."

It was bad enough without exaggeration. And much more lay ahead.

The Next Few Days

Who would have thought a dingy New England factory, in the middle of this selfish and prosaic century, as it is called, concealed such beautiful idylls of innocent affection and cheerful toil, such high romances of noiseless devotion, domestic piety, and ennobling consecration?
—Boston homilist on "The Lawrence Horror"

WEDNESDAY, JANUARY 11, 1860

At seven o'clock this Wednesday morning, a new mournful sound was heard. Like a cheerful giggle at a funeral, the workday morning bells were calling Pemberton employees to the mill. Many of the city's youngsters did what they always did on a Wednesday morning—they went to school. One of them was Harrison, the No. 3 company firefighter who had gone home exhausted in mid-evening Tuesday.

"On the following morning," he wrote later, "I started for school as usual, but on arriving there I found there would be no school that day as a brother of our teacher, Mr. [W.J.] Rolfe, had lost his life at the mill." In fact, all classes were canceled for several days.

As the new day came into full light at the destruction scene, volunteers were arriving to relieve those who had worked through the night. Among the newcomers were more physicians from Manchester, Boston and half a dozen area communities. The wounded were made comfortable before being taken to their homes and boardinghouses.

Throughout the day, relatives arrived from throughout New England in search of their sons and daughters. Some learned of the deaths from reading posted lists. The job of helping anxious relatives search among the bodies fell to Samuel Morey and Daniel L. Plumer, "keepers" at the Dead Room. Morey was the first to volunteer. Plumer, walking several miles from his North Andover home, had arrived soon after the mill collapsed. Although "a man of humble circumstances," Plumer insisted on working without pay.

Barely more than twelve hours after the mill collapsed, twenty-seven bodies had been carried to the Dead Room, "and nearly all showed signs of painful death," a newspaper reported. "They lay as they had been recovered, some naked and covered with blood, or blackened with the dirt and smoke. The faces of many were so disfigured that humanity demanded they should not be exposed."

By six o'clock that evening, the count was up to fifty.

Thomas Nice maintained a vigil in the Dead Room for Mary, his twenty-four-year-old bride. At last, he recognized on the hand of a skeleton a ring that had his name, engraved there as his wedding gift to his wife. He was taken away, "raving wild as a maniac."

In a similar case, an Irish woman was searching City Hall for a male relative, hoping to identify him through a blue scarf and a pin in the shape of a cross. While she looked at the bodies, a male volunteer raised the cloth from covered bodies. He told of his shock on seeing a man's head, the jaw apparently driven into the neck by force of a heavy falling object—and beneath that a blue fabric and metal cross.

Financial help was on the way from Boston in less than twenty-four hours. Newspapers reported, "A meeting of twenty gentlemen was held at the rooms of the Massachusetts Life Insurance Company at half-past one o'clock, in reference to rendering assistance to the sufferers by the recent catastrophe at Lawrence." The group "without discussion… put down their names for $2,000" to be turned over to the New England Society for the Promotion of Manufactures and Mechanic Arts "for distribution." That same day, J. Wiley Edmands presented the gift to Mayor Saunders.

Amos A. Lawrence, nephew of the late Abbott Lawrence, was put in charge of "further contributions." Amos wasted no time. He convened a group in Boston the next day and collected an additional $3,000 to be delivered immediately by "special messenger," J.D.W. Joy. Soon after, donors were being asked to send gifts to Lawrence's Boston business address.

That Wednesday, "a number of gentlemen" canvassed the stricken city to determine the dead and injured. A typical report in Thursday's *Lawrence Courier* stated: "Mr. Duffee canvassed Oak Street and reported Miss Dolan, Mrs. Collins, Caroline F. Mollay, Margaret Gremming as badly injured…Mr. Duffee reported the following as missing on Oak Street: Martha Donnelly, Mary A. Burnham, Mary Murphy."

Despite the variances in spelling, the canvass had the benefit of developing more accurate numbers than the inflated reports of the previous evening. From the survey came the totals of 115 dead and 165 "wounded." The *Lawrence Sentinel* updated the figures on Sunday and came up with 117 dead, 89 missing and 119 seriously injured. The article continued, "As fast as the dead were recognized, they were removed by friends, or taken to the receiving vault at the cemetery."

Still the bodies came, and city officials decided that more mortuary space was needed. They opened a room in City Hall's lower level for unclaimed bodies from the Dead Room. "The corridors and stairways were crowded all the day," a Boston newspaper wrote. "Men and women pushed each other in frantic excitement, and the shrill cries of the women mingled with the deep groans and sobs of sturdy men." It would be days before some would get answers to their frightened questions.

Spectators increased by the trainloads. More than four thousand came from Lowell on Wednesday alone. The 11:00 a.m. train from Boston added twenty cars to accommodate the two thousand passengers. A Boston newspaper reported, "The streets of the city, from one end to the other, are filled with one mass of human beings, everyone eager

Amos A. Lawrence. *Courtesy of the Lawrence Public Library.*

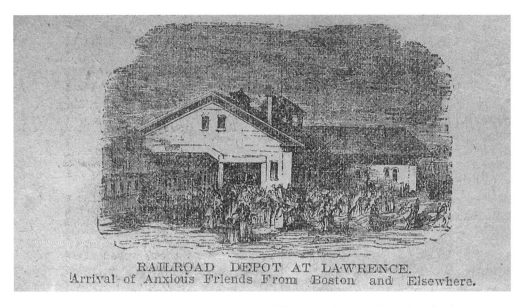

RAILROAD DEPOT AT LAWRENCE.
Arrival of Anxious Friends From Boston and Elsewhere.

Lawrence's railroad depot was crowded with relatives of disaster victims and the curious flocking to the city. *Courtesy of the Lawrence Public Library.*

to render assistance in any way or shape, and all anxious to see or hear what may transpire." Historian Robert H. Tewksbury claimed fifty thousand or more visited City Hall on Wednesday alone.

Food supplies had become a problem. Stores sold out to visitors. Tiger Company's Burredge recalled later, "I heard people say that so great had this city sought to gratify the public by the issue of extras, to meet the demand for something to eat, that the crackers and cheese had been all sold out at the stores." A Boston newspaper recorded "depletion of the larders of the hotels and refreshment saloons…By direction of Mayor Saunders, the attending physicians were provided with entertainment at the Franklin House."

When nearby streets, sidewalks and bridges were filled, people stood on ice covering the canal. Some observers were able to stay warm from the heat still coming from the mill's burning mounds. Hour by hour, crowds watched workers at the wreckage. The scene now, even with light smoke continuing to rise from the ruins, showed the main factory with portions of two walls still standing. The Wing, at the northwest corner, and the chimney, in the southwest, were like battered sentinels on weary guard duty.

Most of the first recorded news of Lawrence's pain came from Boston and New York periodicals. "It is a singular fact," Hayes was to write, "that not one of the newspaper publishers of this city sought to gratify the public by the issue of extras, detailing the events as they transpired. Everything in the form of information came from other places. The magnitude of the disaster seemed to have paralyzed all alike here at home, and for once the thought of 'what can be made' was supplanted by that of 'what can be done to relieve the suffering and the needy.'"

Hayes did not have to explain why *he* had not published an "extra." He had sold his newspaper, the *Lawrence Courier*, exactly one year earlier to John E. Harriman. Newspapers that did circulate in the city had a remarkably similar opening to their stories. For example:

New York Times: "One of the most appalling catastrophes which has ever shocked the country occurred yesterday."

Boston Journal: "A more heart-rending catastrophe we have never had occasion to report."

Harper's Weekly: "The catastrophe which destroyed this mill is almost unparalleled in our history."

Frank Leslie's Illustrated Newspaper: "The news of this most astounding catastrophe has caused a thrill of horror through the whole length and breadth of the country."

New York Illustrated News. "The sudden death of hundreds of unoffending men and women, many of them hardly emerged from childhood, has cast a gloom over our country which no other stirring social incident or political events can dispel."

In contrast, the first edition of the *Lawrence Courier* to cover the event started its lead story with restraint: "On Tuesday afternoon, Jan. 10th, about ten minutes before five o'clock, the usual quiet of our city was disturbed by the alarm that the Pemberton Mill had fallen in on the operatives who were engaged in their labor."

Several newspapers were quick to point fingers at the Pemberton Mill's original owners and the architect, Captain Bigelow. The *Boston Journal* took note of the rumors: "We wait the development of facts…and judge no man." The *Journal* added: "We would charitably hope that no man who lays his head upon his pillow tonight will be haunted by the agonizing cries and the despairing groans of the victims of *his* carelessness, incapacity, or criminal negligence."

Some papers were also alert to capital interests. The *Journal* quoted co-owners Nevins and Howe as estimating the value of the Pemberton at between $600,000 and $700,000. Still standing, the report noted, were the River Building, Repair Shed and Cotton House. The River Building, also known as the Picker and Dye House, had undamaged turbines within its large walls. Two thousand bales of cotton, valued at $100,000, had been untouched in the Cotton House. That helped make up for at least some of the company's loss when B&M freight cars loaded with undelivered cotton were destroyed by fire.

There was more bad news. Fire had destroyed many of the administrative and archival records. When the building collapsed, the paymaster and clerk had been working on the December payroll. Clerk Henry Newhall had left the envelopes and list of employees in his desk as he fled the building. The only hope now was that the sturdy company safe would be recovered, and with it an old payroll. The newest available list of names that officials could recall as being intact went back five months, to August 1859. Nevertheless, having it could help speed distribution of the new—and final—payroll.

By now, Pemberton managers had taken control at the site. Derricks were brought in to lift heavy machinery. A hundred men were hauling rubbish away. Crowds stood into a second night, watching the few volunteers fresh to the efforts as they slowly lifted charred materials in their grim search.

Derricks help move heavy timbers and machinery in search for bodies. Leslie's Illustrated Newspaper, *January 28, 1860. Courtesy of the Lawrence Public Library.*

THURSDAY, JANUARY 12, 1860

Even as bodies were brought to the Dead Room, Dr. Lamb, as coroner, assembled an inquest jury at City Hall to determine not the cause of individual deaths—concussions, for example—but rather why the Pemberton in collapsing had become a killer mill. Outside, the dreary scene was chilled more as rain turned to snow. Because burning material was so deep, firefighters turned their hoses down into the ruins. A newspaper described the scene:

> *The water was gradually congealing upon and encrusting the mass of brick and machinery, which filled and rose above the cellars of the mills. At the same time, the rapidly falling snow was weaving a winding sheet over the dead as it sifted through the crevices of the ruins. Two or three hundred people stood sadly gazing upon the smoldering fragments, and a few men and women wandered over the vast funeral pyre and gazed into the dreadful depths with the vain hope of discovering some intimation of life, or relic of the dead. But little work was done at excavation.*

Already an injured mill worker removed from the ruins had died. Irene D. Crosby, a twenty-one-year-old woman who had come to Lawrence from Warwick, Massachusetts, died January 12, at the Pacific Mill dormitory where she had been living. She had worked at the Pemberton only one week. Celia P. Stevens, twenty-three, from Andover, Maine, died January 21, from head and spine concussions. Mary McAleer, a twenty-one-year-old woman from Ireland, succumbed January 24, the same day as fifty-two-year-old Owen Brennan, also from Ireland. McAleer received arm and hip injuries and "a general shock to her system" in jumping from an upper floor.

The company safe was found that day. The *Boston Journal* reported: "The iron door is warped, but the documents contained therein have been well preserved." The *Daily Advertiser* said that workers, after breaking open the safe, found the inside doors had been left opened, "which accounts for some of the papers being slightly scorched." The records included "several old payrolls and some receipts which may be of service in making up the [pay] list of the sufferers, but they do not contain enough data to make a full and correct list." In addition, the safe had the factory's original architectural plans. These drawings were rushed to the coroner's inquest, enabling the jury "to obtain correct ideas of the mill."

The Pemberton's collapse had a ripple effect on workers in other factories. The Duck Mill next door was forced to shut down because so many employees stayed away. On Massachusetts's North Shore, the Rockport Duck Mill had a scare on Thursday. "On account of the slackening of a large belt, the bell was rung to stop the machinery. Instantly, all the operatives rushed out of the mill in the greatest consternation, fearing that a calamity something like that at Lawrence was about to befall them." The question of mill safety had spread in the Merrimack Valley to the Prescott Mill in Lowell and rumors came from "a general feeling of distrust," as one writer put it.

Mayor Saunders and other city officials were hearing daily from survivors. That helped shorten the list of the missing. It was important, necessary in fact, for the city and Pemberton to account for everyone who had been in the mill that Tuesday. Perhaps typical of those who fled the scene was Ann Lugden. She had survived the fall from her fifth-floor workplace, lay "senseless for an hour," escaped and "returned to Lowell to prevent her mother from suffering anxiety and suspense." Others, no doubt frightened and discouraged, did the same and shifted the "anxiety and suspense" to Lawrence officials concerned for their welfare.

A Boston newspaper reported: "Mayor Saunders receives the visits of a large number of persons daily, who wait on him for the purpose of presenting donations for the sufferers." The item cited National Theatre representatives who, that Thursday, "placed the sum of $225 in gold in his hands."

If visitors were required to wait because the mayor was busy, no one could have blamed him. He would be working all that night, directing crews hired to pull apart the giant machines covering humans dead and, everyone hoped, some who had survived more than thirty hours after the mill's collapse. A search crew came across the body of Margaret Turner, a thirty-two-year-old native of Scotland who had been a bride only one day before becoming a widow. Her father had sailed aboard the USS *Constitution* during the War of

1812, and she had married "Mr. Sargent," the captain of a Gloucester fishing vessel. On their wedding day in 1858, Sargent had left for Georges Bank, but he and his crew were lost in or near those fishing grounds, seventy miles off of Massachusetts's coast. Margaret had resumed her maiden name and left Rockport to work at the Pemberton.

This was a sad day, also, as "bodies and parts of the remains" of nine persons were placed in two boxes and moved to the "receiving tombs" at the city cemetery. The remains of four more victims were to join them before a common burial in late winter. Among them may have been the body of Joseph Bailey. His wife, Mary, apparently never had whatever benefit she might have found in identifying the father of the child she was carrying. Because identifications had not been made, those with missing relatives and friends were left to wonder for the rest of their lives if, in fact, their loved ones were buried on a hill overlooking the city.

FRIDAY, JANUARY 13, 1860

"The city mourned for days," a Pemberton survivor was to tell her grandchildren. "Most of them were Irish, and the Irish would cry and moan in loud voices and you could hear them for days. A lot of them lived in the company houses on Canal or Methuen streets. They would just sit in chairs and rock back and forth and wail. They used to keep going back to see if any more bodies would come out."

Boston Advertiser readers were being informed who was *not* responsible. The newspaper printed a letter signed by mill founder John A. Lowell, disassociating himself from the building's construction and exonerating his brother-in-law, the man who had overseen the work. Wrote Lowell:

> *In justice to Mr. J. Pickering Putnam, it should be stated—and you may do so on my authority—that the Pemberton Mill, of which he was the Treasurer, was built by the Essex Company under the supervision of an experienced Engineer, and by days' work. That Company had evidently no interest in slighting the work; on the contrary, they had every motive, moral and pecuniary, to do it thoroughly. I never doubted, nor do I now doubt, that it was in all respects a first-class mill. Time will, no doubt, develop the causes of the late lamentable catastrophe. To me they are at present veiled in mystery.*

Up to this point, the letter might be read as reflecting the thoughts of a kind and charitable benefactor of the working class. The concluding sentence, however, was intended to protect only John Lowell. "I have the more consciousness of impartiality in this statement," he wrote, "as *I had personally no part in building or equipping this mill*" (author's emphasis added). Some 1860 readers might have been reminded of the noble goal attributed to his uncle, Francis Cabot Lowell—a model mill with the highest standards. And yet, Nathan Appleton had said: "There is no man whose beneficial influence in establishing satisfactory regulations in relation to this manufacture exceeded that of Mr.

John A. Lowell." A stunning contrast was to come about in Lawrence more than 130 years later when the owner of the Malden Mill, manufacturer of a waterproof textile, continued all his employees on the payroll for months after fire destroyed the plant.

In a marvelous example of the power of the press, five men formed what became the permanent Committee of Relief *after* reading that they had done so. Storrow wrote:

> *On the 13th, we saw by the Boston papers that…the names of the Mayor, together with Charles S. Storrow, Henry K. Oliver, William C. Chapin, and John C. Hoadley were placed as a Committee to whom the donors intended to intrust [sic] their funds. With no other intimation or authority than this, the persons thus mentioned held a few moments' consultation together, and determined at once to assume the responsibility with which their names had been connected…On this same evening, this self-constituted Committee met with John R. Rollins, Esq., formerly Mayor of the City, and Mr. George P. Wilson, the City Missionary, both of whom had been devoting themselves with the utmost zeal and efficiency to the sad task of visiting the sufferers and their families.*

The local leaders organized with the unwieldy title of "the Committee of Relief for the Sufferers by the Fall of the Pemberton Mill, in Lawrence, Mass., on the 10th of January 1860." Although Mayor Saunders was already the busiest man in the city, he took on the duties of chairman. It appears that he and Storrow, as treasurer, carried out the bulk of leadership. Saunders could not have had a more appropriate partner. Storrow brought to the assignment an engineer's need for order. More important, perhaps, he brought understanding for those whose loved ones had been lost. When Storrow had accepted the Essex Company's offer to serve as chief engineer in 1845, he and his wife, Lydia Cabot Storrow, had a five-year-old daughter. Over the next few years, Lydia had delivered two more daughters. In the summer of 1849, all three Storrow girls had been taken away by illness. Sarah, only three years old, died on March 25. Less than a week later, Ann, age nine, had followed. The cause of their deaths was listed in city records as "scarlatina." This is an acute, contagious disease today more generally known as scarlet fever. A little more than two months later, baby Catherine, not yet twenty months old, was placed beside her sisters in Cambridge's Mount Auburn Cemetery. "Teething" was given as cause of death.

That Friday, the third day after the catastrophe, bonfires burned dimly and work went on. Before dawn, volunteers found two bodies. Only one of them, "little more than a mass of bones," was identified: Augusta Ann Ashworth. About five o'clock, as darkness covered the area, workers recovered the body of Elizabeth Dunn, a thirty-year-old mother of three. "Her charred remains were placed in a coffin and borne from the City Hall by her friends," the *Boston Journal* reported.

During this time, and continuing for days, burial services were being conducted throughout New England for the Pemberton's dead. For Samuel Rolfe, the twenty-nine-year-old brother of the Lawrence teacher, for example, services took place in his native Newburyport. The same day, Irene Crosby's body was returned to her native Chatham on Cape Cod and Ann Cullen's body to Chelsea. Even as her sister had waited anxiously

Final payroll, recorded in report of city-appointed canvassers, includes Hannah Shea, "dead," owed $28.12, and Kate Sweeney, "missing," owed $25.33. *Courtesy of the American Textile History Museum, Lowell, Massachusetts.*

beside the ruins on Tuesday, rescuers had removed Ann in critical condition. By the time the sister recognized Ann at City Hall on Wednesday, Ann had been dead twelve or more hours.

Mayor Saunders wrote on Friday about his own overwhelming anguish in a letter to Nathan Appleton, who chaired the New England Society's committee for Lawrence:

> *We as yet know but little of the heart-rending agony that is crushing our people. Instances are hourly brought to my notice, which make me long for a time to weep. I have steeled my nerves, yet they almost break. There are many cases which call for speedy aid and sympathy. Nine hundred people upon whom at least 3,000 were dependent for support are out of employment. Young children have lost their parents; brothers and sisters, dependent upon each other, are separated; aged and infirm parents, dependent upon their children, are now childless.*

Like other groups in Lawrence's churches, some twenty women were meeting at the Lawrence Street Congregational Church vestry to work on more than one thousand

yards of unbleached cloth. They made sheets, shirts and other articles "for the relief of the destitute."

Practical considerations were surfacing. Pemberton employees needed money. The payroll papers retrieved from the safe were only somewhat helpful. Company and city officials began working together to construct an accurate list.

Information from the ward inspectors had been compiled in rough alphabetical order in a small bound volume with a black cover. By comparing and merging the list with the paymaster's, company and city officials created a directory of those employed in the six weeks up to January 10. Near many names, inspectors wrote details of employment. That the list had more than a thousand names does not in itself make inaccurate the tally of employees made public after the mill's collapse. The total 918 was most often seen in newspapers. That total, newspaper reports said, included 248 who were not at work when the factory collapsed. Of those at work, 88 were listed as dead or missing, 275 as injured and 307 as unhurt. After the payroll had been met by January 20, some of those listed as missing were reclassified as dead or, having been located, had their names removed from that category.

SATURDAY, JANUARY 14, 1860

"A stranger in the city might not suppose that Lawrence had been so recently visited with the most disastrous calamity that has ever visited this part of the country. Business had been resumed, the mills were all running again with the exception of the Duck Mills, and the crowd of persons attracted by curiosity, or to learn the fate of friends, had nearly all returned to their homes." So the *Boston Post* reported. In fact, Lawrence residents were creating order from chaos that was now five days old. A *Boston Journal* reporter described the work scene:

> *The workmen have cleared a road through the center of the ruins, and are now working both ways, overhauling the tangled and crushed mass of machinery and throwing it towards the center. Anyone who examines the closely interwoven pile into which everything had been packed by the fall and afterwards by the fire, could not believe that anyone could have been alive after the fire had raged. Besides, from the inner depths, when they are exposed to the air, an intense heat arises, which makes this morning a thick veil of steam.*

Everywhere in Lawrence, the signs of a city's troubled life went on. The coroner's inquest jury was hearing witnesses in its fourth day. Clergymen, morticians and cemetery workers made hurried preparations for funerals. One coffin-maker was quoted as having supplied thirty-nine coffins and several boxes in which "the remains of several of the unknown and unwept have been buried." The *Boston Journal* commented on the coffin-makers' "harvest of death."

Daniel Saunders Jr. demonstrated his talent as a writer on Saturday in a proclamation:

In view of the great calamity which has fallen upon our City like a thunder bolt from a cloudless sky, crushing it with a weight of misery which no earthly power can raise—shrouding it in a cloud of anguish which no human hand can dispel—binding it in chains of woe which despair even cannot break, I recommend, and earnestly beseech, that on Tuesday next, all residents of Lawrence, abstain from their usual avocations and labors; that they set apart that day as one of Prayer; that they…publicly ask of God…that He would so order the signal destruction of life and property; that good may come out of this great evil; and that this, our experience, may teach wisdom throughout the land.

All that week, a writer recorded, "bodies were almost hourly recovered and conveyed to the Dead Room." So many bodies had been charred that a black dust was covering equipment and City Hall facilities. "The sled on which the burnt remains are carried to the Dead House," wrote one observer, "has the appearance of a charcoal cart, and the floor upon which they are laid is perfectly black."

With the search force increased to more than two hundred on Saturday, thirteen bodies were located. Only six were quickly identified: Mary Barrett, Elizabeth "Betsey" Dunn, James Harty, Alice Murphy, Mary Nice and Catherine Sweeney. A reporter explained that some were identified only by fragments of clothing. An example was a small piece of fabric from the garment worn by Mr. and Mrs. James Barrett's twenty-two-year-old daughter Mary. When the body was found, Mrs. Barrett fell upon the corpse and fainted.

A funeral and burial were held twice for twenty-two-year-old Catherine Sweeney, a Carding Room employee. A body found on Friday had been identified as Sweeney's by "two thimbles and a comb in the pocket of her dress, and by a bandage on one of her fingers." A wake and funeral took place almost immediately, newspapers reported. A dozen men and women "followed the remains to the grave on foot, the women wringing their hands and giving vent to the most bitter lamentation as the simple cortege moved through the streets." But that was not Catherine. A man identified as John Sweeney, Catherine's father, asked Coroner Lamb for permission, the *Boston Post* reported, "to take away another body recovered from the ruins on Saturday night, which he thought looked more like his daughter than the other." The *Boston Daily Advertiser* said the mistaken body "was exhumed and the proper one, which was identified by her brother, was taken away and buried."

At times, the rattle of repeated bad news was overpowering. After workers had found so many bodies during daylight digging on Saturday, a halt was ordered. A reporter explained: "The workmen had progressed to that part of the ruins where it was supposed a large number of the bodies would be found; and the work was stayed by the fear that these bodies might be unnecessarily mutilated if the workmen should proceed to exhume them in the night…[T]he cessation was caused only by a feeling of humanity."

"The smoke of torment," a *Boston Herald* reporter wrote, was still curling from deep inside wreckage at the south end. Despite the burning, crews with two derricks were assigned that area. Searching for the missing continued on this fifth day of disaster.

Upstream on the Merrimack, a Lowell writer, "*Vox Populi*," was ahead of his time with "a suggestion":

In view of the late terrible calamity at Lawrence, by which hundreds were with scarcely a moment's warning ushered into eternity, would it not be well for the Legislature to provide for the appointment of a competent Board of Commissioners, whose duty it shall be to examine into the safety of buildings where large numbers are employed, or are in the habit of assembling, and order such as are deemed unsafe to be demolished, and make the future erection of such to be a severe penalty? The State provides for a Commission to examine the condition of the banks that a sound currency may be secured, and why should not the security of human life be a subject of still greater importance?

The suggestion was three days late—a state representative had begun action on Wednesday—and thirty years early. Massachusetts legislators were in no rush to force the industrial elite into spending money on employee safety.

SUNDAY, JANUARY 15, 1860

Sunday came with a holy thunder of preaching and most Lawrence churches were filled. A popular Biblical passage, Luke 13:4–5, was chosen by four clergymen. At the Church of the Immaculate Conception, the Reverend J.D. Taaffe had covered candlesticks at side altars in black.

Boston's churches were also ringing with the clergy's conflicting certainty that God had, or had not, caused the disaster. The Reverend William R. Alger told the faithful at the Bullfinch Street Church, "It was not the Lord's hand that smote us, it was a chance that happened to us." The Reverend Mr. Magill, preaching at the Harrison Avenue Presbyterian Church, seemed to lean toward putting God's hand near the divine control switch. A newspaper wrote: "He declared that by the doctrines of the Bible, punishment and calamities were the result of sin." Without suggesting his own stand on God's role, Father O'Donnell, at St. Mary's in Lawrence, suggested "nearly all" of the fifty-five dead and missing Catholics had received divine protection through the last rites.

That first Sunday, the city clergy's fund drive for the poor, planned earlier for another purpose, was redirected to the Pemberton's victims. Already giving time and materials, Lawrence residents would not fail this campaign. Grace Episcopal Church alone raised $1,000.

Tons of gifts were being arranged by categories and distributed from a City Hall space. Two weeks after the fall of the mill, a newspaper recorded the day's count as hundreds of outside garments, undergarments, articles of bedding and bottles of liniment. In addition, "there have also been distributed a great many orders for [fire] wood, large number of bandages, quantities of salve, and, in fact, almost everything."

On Sunday, the ruins had cooled sufficiently and workers were able to scour the main building. Uncovered were the bodies of Lafayette Branch, Jane Thomas and Ellen Ahern. Identifying Branch was not difficult. Despite hand and leg injuries, Branch lay "face upwards, in a straight and natural position," a news account had it. His colleagues on the 1859 Lawrence Common Council had eulogized Branch on Thursday.

VIEW OF THE BOSTON AND MAINE RAILROAD DEPOT, AT BOSTON, EXHIBITING THE RUSH OF CROWDS OF INTERESTED PEOPLE TO THE SCENE OF DISASTER.

Crowds head for trains at Boston & Maine Railroad's Boston station, going to Lawrence as word of the Pemberton disaster spread. Leslie's Illustrated Newspaper. *Courtesy of the Lawrence Public Library.*

Lawrence was more crowded Sunday than it had been for several days. "The streets are filled with flying sleighs, and the hotels are overrun with customers," a newspaper wrote. The death count included fifty-one recognized or identified, twelve not identified and buried on the second day after the accident and nine remaining in the Dead Room.

There was no rest for Henry Lamb. Fortunately for the sake of speed and his own stamina, both services were being performed at City Hall. He was presiding over the daily inquest in the city council chambers and, as the *Boston Journal* wrote, "Every vestige of the human form he must first see when brought here."

MONDAY, JANUARY 16, 1860

The man in charge of clearing the wreckage, T.H. Dolliver, claimed no more bodies were to be found, a prediction more hope than fact, and it didn't last long. At 8:00 p.m., workers removing debris at the Blue House came upon the body of Catherine "Katy" Clark. A widow, she was identified by a fellow boarder at 86 Congress Street who recognized Clark's dress. News of the death was telegraphed to Suncook, New Hampshire, where Clark's five children were living.

At their meeting on this Monday, Relief Committee trustees decided to ask the Pemberton Mill owners to permit the use of one of the boardinghouses "for those who could not be properly cared for at their lodgings," as Rollins said. The trustees saw this as a request to establish a hospital and, Rollins said, "while they were debating the method of managing this a letter was received from Mr. James M. Barnard, a Boston merchant,

proposing to come with a corps of nurses and physicians at his own expense." The company turned over Pemberton 10, across Canal Street from the factory. It came to be called the Pemberton Home and more than two dozen patients were admitted over the next three months.

According to the *Journal*, "a staff of experienced nurses of both sexes" was being recruited. Barnard arrived from Boston with medical students John Homans Jr. and John Stearns Jr., the latter "House Pupil in the Massachusetts General Hospital." Lawrence physicians were at first offended at what appeared to be a plan to bring in professionals to attend their patients and, worse, without notifying local doctors. This led to an explanation from Henry Oliver. A physician himself, he was assisting with Pemberton Home management. Oliver saw no "intentional act of interference." Moreover, Barnard exhibited "the kindest and most unselfish motives." Once the facility had been prepared to receive patients, Homans and Stearns "returned to Boston," Oliver wrote, "and Dr. Samuel A. Green and myself, as arranged beforehand, entered upon our duties." Oliver went on with "a word or two" to "set the matter right."

The hospital census seemed to rise quickly. By January 24, Pemberton Home listed eight female and three male patients. On January 26, Oliver wrote that "their own physicians, Drs. Sargent, Senior, Allen, Burleigh and Morse, were attending to patients then hospitalized. Dr. Green and myself alternate from Boston in the capacity of Superintendent, or House Physician." At some point, J.H. Morse became "attending physician" and doctors from Lawrence and elsewhere volunteered their services. Samuel Morey, as Lamb's lay assistant, "pays his whole attention to the charge and exhibition of the bodies…Cases horrible enough to chill the blood of a veteran he treats with firmness and calmness. Smoking his cigar, which the state of the room makes more welcome, he gives and receives facts for identification of bodies," a reporter wrote.

The other Pemberton boardinghouses, fronting Canal Street and facing the fallen factory, were undergoing major changes during the first days after the disaster. There were empty beds and rooms because of the departure of many female employees. Now that there was no work, many returned to families throughout New England. Many casualties had occurred among this group. Of the one hundred and eighty-four residing in Pemberton 1 through Pemberton 14, fifty were casualties: thirteen dead and thirty-seven injured. Hardest hit was Pemberton 4, with four dead and seven injured among thirty-one residents.

Former employees and surviving relatives and friends were informed early this week that management had compiled a final payroll and set up a distribution schedule. Wages would be given to cover thirty-eight workdays from December 1 to January 10. The distribution was to be made over a three-day period at the Essex Company. The only reliable record appears to be in the small book with black cover among Pemberton records at the American Textile History Museum in Lowell, Massachusetts. It combines both the ward canvassers' reports of employees' health and the amount of money each was credited with earning. Eliminating 40 duplications, there are 996 names in the book. Beside more than a few names was the notation, "has left," which may account for records indicating that 930 pay envelopes were prepared.

Promptly at 9:30 a.m. on Wednesday, Paymaster Clarke faced the line of former Pemberton employees. With so many involved, it was predictable that at least one would try to collect money illegally. The company notice had said, "The money due to those who were killed will be paid to their relatives." A woman showed up at the Essex Company and collected pay intended for the fifty-five-year-old Ellen Roach. Storrow explained: "[Roach] was at first reported killed, but was afterwards classed among the uninjured because a relative, who came for the sum due her upon the payroll of the mill, called herself by her name, and was supposed to be the same person." Roach had been buried in Dorchester, Massachusetts, and her next of kin had been given $75 as a death benefit. There is no record of punishment for the intruder nor what happened to the $10.93 she stole.

On February 2, Chase reported to Howe that the total payroll was $22,118.73. An examination of the roll illustrates gender inequities of the time. Only four females earned more than $40 during this six-week period; the highest was Anna McKee at $47.24. Twenty-eight males, however, earned more than $50, the highest $77.43, by Henry B. Thompson. Of the forty-three who received less than $30, thirty-one were females; of those who received less than a dollar, only one was a male. Among the lowest paid were Margaret Hamilton, $0.42, and Ann Smith, $0.50. Both had been killed on their first day at work.

Pemberton owners Nevins and Howe met their payroll obligation but apparently neither gave to the Relief Fund. As money arrived from all over the United States, each donor's name was listed in newspapers. The owners were not among them. Why did the Pemberton Manufacturing Company not do more than meet its payroll obligation? Nevins's biographer, Richard M. Fremmer, had an explanation: "Lawrence officials were hesitant to even suggest that the mill owners compensate the injured or the families of the dead in fear of causing industry to leave the city due to unfavorable and unfriendly attitudes." Nevins came to be criticized for this, perhaps because he alone remained after taking over his partner's share of the ownership. In fact, Howe had worked pretty much anonymously to help some former employees. In a ledger maintained by the Relief Committee, several unsigned notes refer to Howe's generosity. One says, of "Mrs. Colbert" at 116 Newbury Street, "Mr. George Howe has done all that is necessary and will so continue to do." The writer adds: "There are two of this name." Under an account identifying "Mary Colbert, 258 Elm Street" is the note: "Mr. George Howe has attended to them."

As recovery continued, "Quite a number of the Pemberton operatives are leaving for other places, there being little demand for their services in the other mills," the *Boston Herald* reported. "Several have had tickets furnished them for such places as they wish to go to." In fact, the Pemberton recalled some of the employees January 20, to finish work in buildings that still stood. In the Picker and Dye House, five tons of yarn had been left drying, a process that normally took only three days. Left hanging longer, they would be "liable to spoil," according to a news account. Help was needed also in the Cotton House with warps left on the looms. By the end of the month, factory production under Nevins and Howe was closed. It would be nearly a year before the "new" Pemberton was hiring.

In the meantime, questions were floating throughout the area. Why? How? Stephen Wallis, a mason who had helped build the Pemberton at one point, talked with John Chase, the agent. Could the swaying chimney towering at the southwest corner have been an omen? Wallis said, "There might have been something said by Mr. Chase or myself about it covering up the crack. I'm sure something was said."

This sort of conjecture would continue well beyond this ugly time in Lawrence.

TUESDAY, JANUARY 17, 1860

The day of reflection and prayer ordained by the mayor brought to Lawrence a "quiet as on the Sabbath," the *Boston Journal* reported. "The fears of some that a day's liberty would be largely abused have proved groundless…No scene of drunkenness or ribaldry disturbed the mournful spirit of the day." At the Pemberton site, there was no stopping the derricks and workers. Broken timbers and bricks were being hauled away, of course, but another harvest resulted. "Bonnets and shawls," and other apparel, were being carefully removed and taken to City Hall for their owners' reclamation.

As the day of prayer faded into dusk, six bodies at the City Hall Dead Room awaited identification or removal.

Throughout this second week, spectators continued to crowd Lawrence. Souvenir hunters were creating a problem for overtaxed police. A newspaper reported:

> *Almost every person bore away some relic from the scene of the disaster. A gentleman from St. Louis procured a large bundle, taking not only burned fragments of clothing found upon the victims, spindles, and yarn from the general mass of ruins, but even a part of a brick, and the mortar which came from its surface. Several gentlemen from New York were also ladened with relics. Spindles which were found bright and polished were favorite relics, but any part which could be conveniently carried found a customer. The passion grew to such an extent that orders were given against allowing further acts of the kind, and only a favored few could enter the lines which surrounded the ruins.*

Another account noted, "The police…are busily employed in preventing portions of the machinery being carried off as 'relics'…We have seen some leave the ruins with cogwheels in their pockets, and bars of iron under their coats. A reverend gentleman from Lowell yesterday, by consent of those in charge, bore off several pounds of 'relics' which a couple of industrious reporters had ferreted out of the rubbish and laid aside until they had authority to take them." One arrest involved the theft of jewelry, clothing and money from the storage trunk of Elizabeth Kimball, who had been killed at the Pemberton. The stolen articles were found in the possession of the woman who was arrested.

Among the visitors that Tuesday, nearly a full week after the crash, was Charles H. Bigelow. Now employed in New Bedford, some fifty miles south of Lawrence, he was seeing for the first time the wreckage that was the mill he had helped build. Bigelow's

arrival went virtually unnoticed. Long before the aggressive competition represented by the twenty-first century's "breaking news" delivery in electronic reportage, 1860 newspapers not only had not sought the Pemberton's architect for an interview, they hadn't recorded his absence. Nevertheless, the 1860 reading public was well served. Local and out-of-town newspapers filled thousands of columns with print. It would appear that most of it was accurate and impressively timely. Mid-nineteenth-century city newspapers published several editions a day, quickly setting new type by hand to update a story or to add new details. Speed with hand-drawn illustrations was also impressive in an era before photography was in general use. The *New York Illustrated News* gloated in its January 28 issue that it had "not only got up our first edition within *sixty hours* after the occurrence of the Lawrence calamity, illustrating it with no less than *thirteen* engravings, which presented the catastrophe in its varied phases, but thirty hours later we succeeded in getting up a second issue, still more replete with the faithful and artistic drawings of our *attaches*."

WEDNESDAY, JANUARY 18, 1860

For George Howe, this week brought the grim duty of challenging thirty insurance companies that, together, had written $415,000 in coverage. This would be no simple matter. Gathering the pages of information necessary for filing a claim would take a month. It's possible he was not aware that someone else was in town this day, working on the insurance coverage. Several of the carriers had hired the Saco [Maine] Water Power Company agent to estimate the loss.

THURSDAY, JANUARY 19, 1860

Even as search operations wound down, three parts of the Pemberton Mill stood dangerously above the wreckage. They were the chimney and part of the wall in the southwest corner near the river, the Wing in the northwest corner near the canal and the privy tower approximately in the middle of the west wall. By Thursday, the decision to raze the Wing had been made.

"The city is sinking into its natural calm and placid state. Strangers have left, and operatives have returned to their work," the *Boston Journal* reported. "Only the forces whose duty it is to relieve the wounded and those engaged on the inquest have any further labor. The owners of the mills still have a gang of men at work to save whatever is worth the trouble. The Dead Room is relieved of its burden of bodies, and as there is no prospect of finding any more, the crowd of visitors is greatly diminished."

Virtually no family with two or more employed at the mill went without casualties. In addition to siblings, there were parents with children and at least twenty-eight couples at the Pemberton. Of three Hughes brothers, only Patrick escaped death. John, twenty-eight years old, and Martin, twenty-one, were fatally injured. Mary Crosby's sister

Bridget died and Mary suffered a major head wound. Kate Harrigan had fractures of both arms and a thigh; her sister Ellen, working beside her, was only slightly injured.

Irony marked death in the family of Mrs. Ellen Bryan Hannon, who had already lost both her husband, Daniel Hannon, and a daughter during Ireland's famine. In 1860, sons Elias and Dennis and daughters Catherine and Ellen all worked in factories. When the Pemberton collapsed, Catherine escaped and looked unsuccessfully among survivors for her sister. To continue searching, Catherine disappeared into the huge pile of wreckage even as Ellen made her way to safety, according to family tradition. Catherine's body was found later.

FRIDAY, JANUARY 20, 1860

Pemberton Home received the first patients this day. The *Journal* reported: "It is hoped that as many as have not so comfortable quarters will be induced to accept kind and skillful treatment here." Joining volunteer physicians and nurses from Boston on the staff were "ladies noted for their deeds of charity."

Lawrence physicians, the *Journal* reported, "may be seen at all hours of the day, and nearly any hour of the night, driving from house to house upon their melancholy errands. In some streets, in the outskirts of the city, scarcely a house but has its victim of the calamity."

Dolliver's cleanup crew did not finish examining every area within the mill until January 20. Bodies removed during the last days were, a newspaper reported, "almost entirely destroyed." Only bodies that had been cremated were to remain in the ruins as unrecoverable ashes. Once it appeared certain that no more could be done, the work of clearing the site took on an orderly sequence. Large objects—machinery and sections of flooring and walls—were the first to be taken, as much for safety as to speed the process. Salvaging useable materials and equipment was part of this operation. The workforce was limited to former Pemberton employees now unemployed. Hundreds who had been hired temporarily in the search and rescue efforts were let go.

Various organizations by now were recognizing special—even heroic—efforts of valor. The Washington Mills cited the efforts of Captain Gustavus V. Fox, J.H. Dana and B.F. Watson in "A Card" published in a newspaper. Indeed, Fox was to become one of the city's best-known success stories. During the Civil War, he was Abraham Lincoln's assistant secretary of the navy. But in early 1860, at age thirty-eight, he may not have been much more than a millhand to the outside world. The *Boston Journal*, reporting on the Pemberton disaster, spelled his last name "Fawkes."

The Lawrence Brass Band honored its member, Richard H. Lunney, draping the Band Room "in mourning for thirty days." Lunney, age thirty-two, was removed from the wreckage but died the following day. His body was sent to his native Springvale, Maine, for burial.

The perpetual motion of Mayor Saunders carried him beyond all administrative needs. The city was being flooded with letters "from all parts of the country containing

anxious inquiries," and the mayor, with help from Relief Committee members, answered them all. Saunders was everywhere. He was busy in his office and visited in other City Hall rooms. He was at the ruins. He stopped by Pemberton Home. He was in the streets, a figure of vigor and reassurance, until January 25. Walking on Commercial Street, making "his customary visits to the wounded and sick, he was suddenly attacked with a fit of fainting, caused by overexertion," the *Journal* reported. Carried to his home, the mayor rested for only a few hours and went back to a mountain of correspondence awaiting responses.

The Committee on Relief

Noble souls, through dust and heat,
Rise from disaster and defeat the stronger,
And conscious still of the divine.
Within them, lie on earth supine
…No longer.

—*Henry Wadsworth Longfellow*

With Mayor Saunders and Charles Storrow in charge, the Relief Committee had gone to work quickly. Six men were "visiting and inspecting the wounded, and collecting the necessary information in regard to their names, residences, condition, and wants." These "canvassers" were Sylvester A. Furbush, First District; J.Q.A. Batchelder, Second District; William D. Joplin, Third District; Henry Withington, Fourth District; Elbridge Weston, Fifth District and Daniel Saunders, the mayor's father and himself a former mayor, in the Sixth District.

The committee set up a system that was to function for thirteen months. The January 15 meeting established pay rates ($2 a day for the clerk, $1.50 for each of six inspectors) and designated offices (in the city assessors' rooms). Later, the committee agreed to pay physicians but required them to "specify [the] charge for each case, not the aggregate." The final report recorded all expenditures, case by case, penny by penny.

On January 16, the committee established ground rules. After determining that relief efforts would be directed only to Pemberton "sufferers," the trustees, as they called themselves, voted guidelines: "Clothing loss is not to be replaced, but the naked destitute to be clad," and "Loss of employment is an ordinary occurrence which we cannot remedy, but we can help to find employment or give a railroad pass to go to their friends." The committee concluded sternly: "Our fund is for relief of extreme sufferers."

In fact, help was given to just about everyone in need who asked. A newspaper reported that two Catholic priests were advising the good-hearted to limit the donations for "the Irish" to necessities. In an article in which immigrants are clearly segregated from "the Americans," the *New York Times* gave this report, so significant for its cultural undertones:

Charles Storrow. *Courtesy of the Lawrence Public Library.*

Advertisement testifies to services available to newcomers from Europe in the 1850s. *Courtesy of the Lawrence Public Library.*

> *Father O'Donnell suggests that nothing but articles absolutely required for the health of his people be furnished them, and that all further charities be directed to American people. His word seems to be law among the Catholics, for he is much venerated and beloved by them, and, so far as my information and observation extend, very justly…Father Taaffe, too, is less bigoted than Catholic priests generally have the reputation of being.*

At first, the trustees considered individual cases. The matter of Richard Lunney's wife was "disposed of by giving her $50 and passage fare to Berwick, Maine." Walter Lannon was "discharged" with a coat, cap and railroad fare to Biddeford, Maine; and young Charles Morgan, who had worked at the Pemberton less than a week, earning only $1.67, was sent to Biddeford by rail with *two* coats, a cap and boots.

Such detailed management soon became too much for the trustees, and they authorized Saunders and Storrow "to settle all cases needing immediate aid." That would cover just about everyone. The canvassers, however, made some judgments. An inspector came upon a person identified as Barney Donnelly and recorded his status:

"Is not a sufferer, is a vagrant." There remained a nagging question, however, and the committee authorized Saunders to recommend "the legal steps necessary to be taken." Understandably, none of the trustees wanted to have personal liability for the Relief Fund. "Vagrant" Donnelly, it appears, may have had some connections, after all. He is listed in the final payroll as having been given $1.50.

"[F]rom this moment," wrote Storrow, "contributions of every kind, in money, in clothing, in medicines, in furniture, in provisions, with offers of medical aid, of free beds in hospitals, of service as nurses, watchers, and physicians were hourly arriving." Philadelphia book publisher George E. Evans contributed $1,000 and proudly recalled he had "begun life as a Lawrence factory boy." A more contemporary "factory boy" was given special recognition through a gift sent to Mayor Saunders. G.H. Whitman donated "two gold pieces, $20, and, selecting the recipient,…the boy John Shaw, for saving three lives on that fearful night." In fact, a newspaper said Shaw "was the means of saving no less than *six* lives." In another contribution to an individual in the news, Isaiah Anderson of Yonkers, New York, gave $5 for Mary Ann Hamilton, whose daughter Margaret had died.

Gifts were not confined to money. Isaac Fenno & Co. of Boston sent a case of clothing. From "the ladies of Chelsea" came "three cases and three barrels of clothing, mittens, undergarments, bandages, etc." Daniel H. Brown of Philadelphia was among several who shipped ointments and liniments for burns, abrasions and other conditions.

Newspapers seemed determined to record every penny from donors. A typical day's report almost two weeks after the Pemberton's collapse included the following: $40 from Barnicoat Engine Company of Boston; $5, William Wyman, Lowell; $5, E.G. Friend, Gloucester; $135, male operatives, Stark Mill, Manchester; $129.25, operatives, Nos. One and Two Amoskeag New Mills; $50, Reverend O. Conevan, Dover; $100, George C. Ballou, Woonsocket, Rhode Island; $1,000, citizens of Providence; $100, operatives of Mills and Machine Shop, North Andover; $435, members of New York Stock Exchange; and $75, Chandler & Co., Boston.

The canvassers literally walked house to house. Their reports became more detailed as the inspectors became more experienced. On January 18, one wrote that Catherine Kennedy "had $5.1/2 in her pocket which she lost." Two days later, the committee reported: "The following persons have gone to Gt. Barrington with Mr. Jas. W. Fales to work—gave them passes to Boston and a note saying that they were sufferers… Michael Carney (gave him coat that was brot back); Irene Carney (his wife; gave her shawl and bonnet); Albert DeLisle, Mathew Robinson, Edward McGinnis, John D. Arnot, Edw. Hayes."

Even as funds arrived, leaders were considering a time limit on collected funds. On January 20, Amos A. Lawrence wrote "suggesting that if a sum sufficient for relief had already been obtained, it would be well for the Mayor to announce it." Three days later, with committee approval, Saunders addressed a letter to the public announcing that "we are most happy in believing that what has been already sent, with what is now pledged and already subscribed, or now in the hands of persons who have kindly solicited subscriptions, will be sufficient for the wants of those really needy, and those to

be provided for in continuance. If not, the liberality of our own citizens will not permit any families or individuals to want the aid and comfort which their necessities may require." Moreover, he added, the committee did not wish to "divert [gifts] from other worthy objects of charity."

News even then traveled fast. The next day, January 24, Mayor Joseph Grinnell of New Bedford, Massachusetts, wrote that his citizens had collected funds for Lawrence, but learning of the "moratorium on collections," as Storrow put it, they "would instead distribute the proceeds among the unemployed in their own city."

The Massachusetts Legislature had considered Lawrence's needs. The House Committee on Finance was directed to "inquire into the expediency of appropriating a thousand dollars." Before any action was taken, however, Henry Oliver, state representative from Lawrence and a committee member, moved successfully that the matter should be "discharged from further consideration." The reason was that the Relief Committee, of which Oliver also was a member, had ended public bequests.

After a few weeks' experience, Relief Committee members widened their definition of the unemployed to "destitution for want of work" and declared: "This is temporary only and is to be temporarily relieved but wherever there is destitution the relief is to be given—either in money, clothes, fuel, provisions, rent, or otherwise"

Generosity was about the only thing not in short supply that winter in Lawrence.

The Inquest Begins

Section 1. Coroners shall take inquests, upon the view of the dead bodies of such persons only as shall be supposed to have come to their death by violence, and not when the death is believed to have been occasioned by casualty.
—Massachusetts General Laws, Chapter 140 (Revised Statutes, 1836)

As a coroner of Essex County since 1854, William Lamb had wasted no time in ordering an inquest into the deaths at the Pemberton Mill. He convened a jury on Thursday, January 12, less than forty hours after the building's collapse. The legal notice was a warrant directing "the Constables of the city of Lawrence to immediately summon and warn six good and lawful men of said city to appear before [Lamb]…to inquire upon a view of the bodies of John Dearborn, Mary McDonald, Bridget Ryan, Margaret Sullivan, Maurice Palmer, Bernard Hollifield, Ellen Roach, Margaret Follen, Hannah Mulinex, Joanna Cronan, Bridget Loughery, Peter Callahan, Dennis Leonard, Hannah Shay, Mary Howard, Joanna Hurley, Catharine Conners, Eliza Orr, Michael O'Brien, Ellen C. Ahern, Ellen Sullivan, and Jeremiah A'Hern, there lying dead, how and in what manner they came to their death."

As it developed, two of the names should not have been listed. The body identified as belonging to Ellen Roach was, in fact, that of Ellen Dineen. "A'Hern," whose name was actually spelled "Ahern," was not among the original group. The body was that "of a youth whose name is to the jurors unknown."

Constable Alanson Briggs certified that he had called for jury duty Leonard F. Creasy, James H. Dana, Edward Page, Stephen P. Simmons, Leonard Stoddard and William H.P. Wright, who was appointed foreman. At a time when women were not permitted to provide civic services, the jury appeared otherwise to generally represent the community. It seems unlikely, however, that Briggs simply went out onto Common Street and stopped the first six men he met. One can wonder if Dr. Lamb may have suggested some of those to be recruited. It seems reasonable that jurors were expected to identify the chief suspects from among those who had erected the building or made changes in the seven years since its construction. A jury of their peers, therefore, would include people familiar with construction.

William Wright, a young attorney in 1860, headed the inquest jury. *Courtesy of the Lawrence Public Library.*

In fact, five of the jurors worked in the building trades: Creasy, carpenter and partner in a building company; Dana, iron and tin worker; Page, drive-belt manufacturer; Simmons, stone mason and contractor whose many area jobs included the dam and other Essex Company projects and Stoddard, carpenter and general contractor. It might be argued that some of them may have been so closely identified with the Pemberton Mill that they might not have been able to bring objective reasoning to the evidence and testimony. Captain Bigelow, the engineer who had designed the Pemberton and Pacific Mills, and who was charged with supervising construction, had worked with—probably even hired—one or more of the jurors.

The foreman, Wright, who was to serve as chief interrogator of witnesses, was an attorney and an up-and-comer in Massachusetts's North Shore politics. Both the *Lowell Citizen & News* and the *Lawrence American* had unsuccessfully urged him three years earlier to seek an unexpired term in the United States House of Representatives.

The inquest clerk was Caleb Saunders, the mayor's brother. Only twenty-three years old, Caleb was studying law in his brother's practice. Young Saunders maintained a hearing transcript, which J.F.C. Hayes recorded as "nearly forty large octavo pages of closely printed evidence." The only surviving record, however, comes from newspapers.

Jurors are expected to come to hearings with open minds. To achieve that would be a great credit for this jury. All were Lawrence residents, and they had doubtless been

reading newspaper coverage of the disaster. Within hours of the building's collapse, the architect and the plans had been widely condemned. For example, on January 12, less than forty-eight hours after the first rumbling at the Pemberton, the *New York Times* editorialized: "The Pemberton Mill…was insecurely constructed originally. It appears that the work on the building had to be entirely suspended before it was finished, so hazardous was it deemed to continue it…A building of this description is filled with heavy machinery, whose working would have the natural effect of loosening its connections, and is crowded with human beings with utter recklessness of consequences which it was almost impossible not to have apprehended."

A *Times* reporter, however, had another slant on the matter. He wrote in the news columns of the same issue: "The statement that the mill was a notoriously unsafe building is not generally credited. I have been informed by the Mayor, by some who saw the buildings erected, and by some of the employees, that they did not hear until this accident that the building was unsafe."

The *Boston Evening Traveller* checked in the next day: "The assertions which have been made that the mill was considered as safe as any in the country…are upon the very face of them absurd and false…soon after it was erected, it was found necessary to support it by numerous iron girders or braces, shows it was weak."

Beneath a January 21 *Harper's Weekly* headline, "The Slaughter of Lawrence," the newspaper editorialized: "If the evidence bears out these assertions, a responsibility at which all good men will shudder weighs on the proprietors of those mills; they are, in fact, before God and man guilty of the deaths of some two hundred innocent creatures."

And so, it was in this environment that jurors, coroner and dozens of witnesses gathered daily at City Hall. Even if the jurors were not affected by what they read or by discussing the deaths of so many, they had grim reminders each day. The room where they sat was not far from the temporary morgue in the auditorium. Newly recovered bodies were, in the words of Dr. Lamb's warrant, "there lying dead."

Surviving records indicate the inquiry was thorough and made without haste. (The testimony quoted throughout this chapter appeared in 1860 newspapers. A typical report eliminated the witness's use of the personal pronoun and connected independent statements with semicolons. Without changing the testimony itself, the author has used the pronouns "I" and "we" and created separate statements where it seemed important to do so in order to achieve a more natural record.)

As coroner, Lamb's job was to guide the hearing in the way of a courtroom judge. He was not afraid to agree to suggestions from "men more thoroughly acquainted with the subjects under consideration," the *New York Times* said. Several areas of disagreement—some relatively minor, some significant to a finding of responsibility—developed during testimony. It was not unusual, perhaps, that masons might have differing opinions about the benefits of, say, Vermont lime in mortar rather than Thomaston lime. Minor and major points in dispute concerned the materials and methods that had been used in the construction. At issue in such cases was who had prepared the design or specifications, who had ordered the materials and who was responsible for quality control.

As the hearings went on, it became crucial for the jury to know who had inspected materials delivered to the site. As men professionally involved in construction, the jurors would have known how the duties in such projects were almost always assigned. They would know who—owner, architect, engineer—would normally have ordered the lumber and cast iron and bricks. Most important to this case, they ultimately needed to know who had checked arriving materials.

There were two key figures in meeting these responsibilities: John Pickering Putnam, who had served as agent for John Lowell, his brother-in-law and the principal owner; and Charles Henry Bigelow, architect and engineer.

Bigelow introduced a protocol he said was generally practiced by mid-nineteenth-century industrialists in requisitioning material supplies. Bigelow, assigned by the Essex Company to oversee the Pemberton's construction in 1853, told the jury how the system worked: "If we want a machine, and go to a man whose business it is to make such machines, we expect it will be a proper one when we get it."

In other words, protocol—the system—was based on trust. People who provided building materials were *expected* to make and ship only their best. It was a matter of honor to Bigelow, a retired army captain. James B. Francis, a highly respected Lowell engineer, supported this philosophy. Francis had helped design many factories during his twenty-three years as chief engineer of the Lowell Locks and Canal Company. Francis also had served Putnam as consultant on some of the Pemberton's building materials, notably the cast iron pillars. Francis told the jury, "We have divided things off in such a way in Lowell that each man is responsible for his own work."

Francis's testimony was offered in the most formal and courteous manner, but as he went on his opinions were damaging to Bigelow's reputation. On the one hand, he seemed to exonerate Bigelow—"The engineer has discharged his duty when he has made the plans"—but on the other hand, he found fault with Bigelow as the architect of the Pemberton Mill's plans.

Picture Francis and his impact on a jury. He had become by then, at age forty-five, a man of rotund body with unblinking eyes that peered from beneath long, heavy eyebrows and a forehead extended high onto a balding pate. His appearance supported his unassailable reputation.

Examining Francis on the subject of the metal columns' strength, the jury foreman, Wright, asked, "Was this shoring, in your opinion, in any way insufficient?"

Francis answered: "I am in the habit of coming at these things by figures. It is useless to guess when a fact can be so easily demonstrated, if I can know the weight to be supported." He then systematically established his estimates for the weight of everything above the first floor in the Pemberton Mill—machinery on four floors, shafting, five hundred people, stock, piping, columns and even the flooring and roof. The total was about 2,144 tons. Fifty-four first-floor columns were supporting that weight—in excess of 4.2 *million* pounds.

A complementary factor with weight was the square footage each pillar supported. Francis noted that in the Prescott Spinning Mill in Lowell, for which he had drawn plans, each pillar was supporting 128 square feet of the floor above, or 512 on four

floors. "In the Pemberton," Francis said, "the spans were 26 feet 10 inches by 10 feet, giving an area of 268 feet 4 inches, and on four floors, 1,073 feet 4 inches." The result, Francis concluded: "Each column had to support double the weight at the Pemberton Mill as at the Prescott. This, of course, is assuming that the weight per square foot of floor is as great at the Pemberton as at the Prescott, of which I suppose there can be no doubt."

In scholarly testimony, Francis traced mathematical and engineering rules covering weight-carrying capacities generally understood and followed by contemporary architects. He quoted a British engineer who had conducted experiments on pillars of standard sizes and dimensions. Francis went on to describe his own computations, working with pillars taken from the Pemberton ruins.

The weight supported by each column on the lower floor, Francis estimated, was twenty-five tons. On well-made columns, that would have been within the range of safety "according to the rule given by [Eaton] Hodgkinson," he said. "But as the columns turned out," he continued, "the weight of twenty-five tons on the pintle being more than one-half of the breaking weight [of forty-five tons on a poorly cast pillar], I should consider to be entirely unsafe. If these columns had been as good as they ordinarily are, and a pintle had broken, I think it would not have endangered the mill."

After all the engineering calculations and mathematical formulas had been applied, Francis's testimony came down to one central question. His answer would reflect heavily on the architectural plans of his colleague, Bigelow.

Was the Pemberton Mill safe as constructed?

Francis concluded: "I think there should have been another row of columns in the mill."

In a second day before the jury, Francis shot another arrow into the target that was Bigelow's professional reputation. He added: "I think the falling of the whole mill is attributable both to the columns and the walls. I mean that the whole mill would not have been ruined by the breaking of one or two columns if the walls had been of proper thickness."

Bigelow's double duty as architect-engineer complicated the matter of responsibility sufficiently, but another factor was involved. Normally, the Essex Company sold land and power rights, and then built a factory according to the needs of the investors. An exception had been made in this case. Bigelow told the jury: "The nature of the arrangement…was such as to leave…the Pemberton party having the right to make contract or employ forces as it might suit them, and we [Essex] were glad to have them do it; and they did so in repeated instances, such as making contract for the glass, all the shafting and gearing, for the iron columns, and to add force to the carpentering and other departments of the work."

Bigelow went on to explain the role of John Pickering Putnam, "managing director and financial agent of the owners." Bigelow told of their "mutual friendliness and respect" and added, "[Putnam] always went for the safest and strongest structure that we knew how to build, *with due regard to economy*" (emphasis added). Putnam had, in fact, made several changes in Bigelow's plans after consulting James Francis on some building materials, notably the cast iron pillars.

Broken pillar on display shows how side walls varied in thickness. *Photo by Jim Beauchesne. Courtesy of Lawrence Heritage State Park.*

There was a third key player, and in referring to him Bigelow again introduced the matter of honor. He testified: "I placed Mr. Benjamin Coolidge in immediate charge of the work at the Pemberton Mill. He was to reside there, and he did. He spent his days there, and his nights, if necessary. Mr. Coolidge superintended the work with a vigor and fidelity that was untiring. His intelligence as an engineer and as a man is well known in this community, as well as his honor as a gentleman and a Christian. He was to be my eyes and my hands, constantly present as far as we could make him so."

Bigelow earlier had suggested that men of honor would ship only perfect metal pillars and so a works superintendent need not examine them upon delivery. Coolidge demonstrated his awareness of this. He was asked by Wright, "Do you think the walls were strong enough, considering the length and width of the mill and the weight on the floors?" Coolidge responded: "It is not the business of the deputy engineer to criticize, but simply to obey the orders of the chief. I formed no opinion on the subject."

A fourteen-year Essex employee, ten of those years with Bigelow, Coolidge was thus exonerated by Bigelow. His devotion to business principles and his efforts on behalf of both the Essex Company and the Pemberton were never in question. For the jury, then, that narrowed the focus to the men who really had charge.

In Bigelow and Putnam, the jury was faced with two imposing figures who, if not Brahmins themselves, were within the circles of kinship. Bigelow's first cousin, Katherine Bigelow, had married Abbott Lawrence. The Lawrences had named one of their sons

"Bigelow Lawrence." Putnam was the brother-in-law of John Amory Lowell, whose second wife was John's sister, Susan Cabot Putnam.

Bigelow was a West Point man and a veteran of eleven years in the U.S. Army Corps of Engineers. At the time of the Pemberton disaster, Bigelow was serving as superintendent of government works in New Bedford. Essex Company service was two years behind him. That Bigelow was respected is evident in the list of major projects he had supervised throughout New England. Maintaining trust and being "Christian" were important to him. He had served in 1856–1857 as a vice-president of the New England Emigrant Aid Society, the organization that Amos A. Lawrence had led in its mission to populate the new state of Kansas with antislavery settlers. Bigelow, in 1854, had "led off in Essex County, Mass., in the anti-Nebraska excitement." In short, he "has ever been distinguished as a bitter and rabid Abolitionist," a New York proslavery newspaper complained.

Honor was a hallmark of the Bigelow family. Captain Bigelow had a brother serving on the Massachusetts Supreme Judicial Court. He was himself the son-in-law of the former governor of Massachusetts, George N. Briggs. All of this led the *New York Times* to remark: "Captain Bigelow…partly, perhaps, in consequence of his social position, as well as from his reputed skill in engineering—was regarded as a competent person to be engaged in the direction of the first important works in Lawrence." The newspaper erred, however, in suggesting that Bigelow was responsible for the collapse of a cofferdam during 1846 river work. If there had been a blunder because of design, it was not Bigelow's fault. Charles Storrow had designed the structure before Bigelow joined the Essex Company.

Open to question even now are some of the key decisions in the Pemberton's construction. Putnam initiated several changes in Bigelow's plans. Bigelow had gone along with Putnam's proposals and so, in his way, was functioning in relation to Putnam the way that Coolidge related to Bigelow: "It is not the business of the deputy…to criticize, but simply to obey the orders of the chief."

It is likely that the jurors knew important characteristics about Bigelow and Putnam from experiences before the Pemberton's collapse. Each of the two had reputations for being strong, accustomed to making decisions, taking responsibilities and yet willing to accept others' decisions. Bigelow made it clear that he accepted overall responsibility for the efforts and judgments of his assistant and site superintendent, Coolidge.

Putnam, on the other hand, had fallen from the Lowell family's favor by 1860 because of his own mishandling of family trust funds during John A. Lowell's absence a few years earlier. That was no small matter. Their relationship as brothers-in-law aside, Putnam had been Lowell's long-time adviser, friend and legal representative. When he helped found the Pemberton company in 1852, Putnam was no newcomer to manufacturing. He had succeeded John Lowell as the Boott Mills treasurer in 1848, when Lowell retired.

Determining which man was responsible for failed work at the Pemberton Mill, therefore, would be dependent first upon precisely pinpointing the area at fault. Was it a brick wall that was too "thin?" Or a foundation that shifted? A crafted timber beam

Foundation from original 1853 mill supports the new 1860 building, still standing in the twenty-first century. *Courtesy of Alvin F. Oickle.*

that was too short? A sagging floor? A cracked pillar? If Bigelow's and Francis's protocol were taken as the proper path to fixing responsibility, the jury's mission came down to this: Find the fault, find the guilty man.

If Bigelow was not one to point a finger, he seemed in some of his testimony to be placing himself on the fringe, if not on the outside, of the realm of responsibility for change orders and supplies ordered by Putnam. Bigelow designated for the jury several potential areas of faults:

Pintles: "I received the suggestion [to use pintles] from him, and made up my mind that they would bear up enough weight, vertical pressure, and so told him."

Brick walls: "The mill was a model to experienced persons for its steadiness and the approach to perfection with which it run all the time it was in motion. A year or two after the mill was completed, I was in and out constantly to see how it went. The delicate bearings of the heavy shafting at the south end were always remarkably true."

Cast-iron pillars: Bigelow read several letters he and Putnam exchanged about the use of pillars. Bigelow's plans called for wood. Putnam favored cast iron. Bigelow told the jury: "The theory of the experiments found in the books, and the practice in other mills, both go to show that there was an ample margin of security in the dimensions of the pillars—the order being to render the margin enormous. I have no doubt that they were bought in absolute good faith by Mr. Putnam. The only error I can see in his course was in buying them at so much apiece instead of so much a pound."

A modern expert, Gerald K. Geerlings, has an urgent message—do not accept careless cast-iron work—that would have served as a warning to Bigelow, Coolidge and Putnam, had it been written and read eighty years earlier. Geerlings writes: "By the time the iron is ready for delivery…it is futile for the architect to blame poor cast iron work on anyone but himself, for had his details been issued on time, and the shop-drawings promptly checked, he might have demanded that the iron be cast far enough in advance so that it could be inspected at the foundry. A foundry requires the greatest time on the work in the preparation up to the point where the mould can be poured; if the casting turns out poorly, it is only a matter of another day to pour another one, and if the architect inspects its quality *then*, there will be no reason for honey-combed surfaces on delivery at the building."

Geerlings goes on to say that foundries whose workers seek excellence "report that their greatest sales obstacle is the education of the architect to the differences between a good casting with smooth surfaces and invisible joints, and a poor one full of flaws and unsightly fittings."

Harsh criticism unrestrained, Geerlings concludes: "[U]nless the architect be of unusual nature, he will attend ten concerts and one hundred theaters in his prized opportunities for relaxation, before once seeking out a single cast-iron foundry."

Bigelow did seem to fall completely within Geerlings's definition of the errant architect. He was on record as having refused to visit the foundry:

I received a letter from Mr. Putnam in April, 1853, saying, "Mr. Fuller has the pillars done. He wants you to send somebody down to inspect them. He says they are first-rate

pillars, but wants you to send down, so if any are rejected he can save the freight." We refused to send a man down to inspect them. They were to be delivered here. No one was sent there. It was merely a request on his part for his own private advantage.

When the subject turned to testing the pillars, Bigelow said: "I never knew of any test for casting, except to examine them on the outside…We gave the pillars an ordinary inspection, and received them in good faith." In fact, Coolidge had checked the newly arrived pillars. He told the jury that even though he "condemned the first lot," they were used anyway "in various parts of the building, and the contractor was warned to send better ones."

The *Boston Herald* concluded its January 17 report: "It may be that the breaking of one of these pillars caused the accident, but if the fracture of a single support can tumble down an entire building covering an acre of ground, it is time that some other plan should be adopted for our manufactories. The result shows that engineers can be mistaken."

Charles Wright, the man who superintended installation of the Pemberton's running machinery, would have agreed with the newspaper's thesis. He complained to a New York newspaper during the inquest about lack of testimony on what he considered a major structural failure. He said he had spoken with both Putnam and Samuel Lawrence in 1853, about what he regarded as the insufficiency of the wheel pit foundation. "This point, I am sure," he asserted, "is where the fearful crash commenced. I am confident that with the drawings in the possession of Messrs. Corliss & Nightingale, I could clearly show this."

Wright was never called to testify.

With the testimony of James Francis on January 24, inquest testimony was concluded. The jury was given time off that next day. Over a span of sixteen days, the jury had heard more than fifty witnesses during twenty-two sessions. The jurors and the coroner's staff had recessed on one Saturday and two Sundays, otherwise meeting every morning, most afternoons and—in what must have been an exhausting three-a-day marathon—for evening sessions January 16 through January 19. Samples of some of the building materials had been shown as evidence, and the jurors had a detailed look at the disaster scene. Recalling this experience in later years for a newspaper reporter, Dr. Lamb said: "The inquest which I was obliged to conduct…was doubtless the most searching and exhaustive of any on record." The physician's assessment should not be taken lightly; he served as coroner more than forty-one years.

On Thursday, January 26, the decision was in the hands of jury foreman Wright and the other five members. Who was to be blamed for the fall of the Pemberton Mill?

One of the more thoughtful editorials appeared in the *Boston Daily Advertiser*. In the calm verbiage of analysis, the writer considered all aspects of testimony regarding building conditions and concluded "[W]e must lay the responsibility for its fall upon the defective plans and the actual omissions of the engineers…Why they failed…does not appear, except that one of them says that he was at the time at work upon another mill and much driven—a reason which might have been good cause for declining this work, but not for failure after undertaking it."

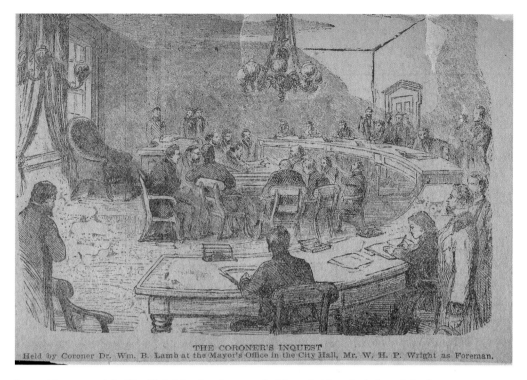

THE CORONER'S INQUEST
Held by Coroner Dr. Wm. B. Lamb at the Mayor's Office in the City Hall, Mr. W. H. P. Wright as Foreman.

Inquest jury at work in City Hall. Man leaning over desk is probably a depiction of the foreman, attorney William Wright. *Courtesy of the Lawrence Public Library.*

The *Boston Herald* expressed the same conclusion in more colorful language. The Pemberton ruins "puzzled the engineers awfully. They can't understand it upon any hypothesis except that the iron pillars broke down like so many damnable sticks of sugar candy." And, a few paragraphs later, "Let the engineers say what they may, and the jury decide as they will, the world must know that the Pemberton Mill was a sham affair."

So, Boston newspapers laid the blame on two engineers—Bigelow, who at the time of the Pemberton's collapse was personally supervising a second project in Lawrence (construction of the Pacific Mills), and his assistant, Coolidge, the on-site supervisor.

Soon, the only opinion that counted would be announced. The jurors by the end of January had agreed on their findings. Led by the foreman, Wright, and with Coroner Lamb keeping watch, the six men began crafting a long statement to cover their findings.

The Jury's Verdict

"The duties and responsibilities of the different persons acting together do not, however, appear to have been defined with much precision; all seem to have been anxious to promote the enterprise, and all undoubtedly acted in good faith; but, among them, they committed the errors which have been followed by such awful consequences."

–Journal of the Franklin Institute

The coroner released the verdict in the Pemberton Mill case on February 2, 1860. Most Lawrence and Boston area people would have learned of it from reading the *Boston Journal* that Friday or by word of mouth.

It appears that Dr. Lamb, in a way similar to a modern press practice called "pooling," gave a copy of the eight-page final report to one newspaper representative to distribute copies to all newspapers. The *Journal*, on February 7, explained why it had "exclusively" published the verdict in its February 3 editions. The brief explanation expressed "regrets" that the telegrapher had been given the copy but "no explicit directions." The *Journal* wrote: "Had we known or suspected that the other morning papers had not received it, according to the understanding, we should have sent slips. Our contemporaries will do us the justice to believe that we would pursue a fair and honorable course in such matters of editorial comity."

There were no screaming headlines. Even the *Journal's* story carried a typical series of three lines over a one-column report:

THE LAWRENCE CALAMITY
Verdict of the Coroner's Jury
Severe Censure of Capt. Bigelow

The last five words neatly summarized the 2,500-word verdict, which probably was written by Wright with contributions from Lamb and Caleb Saunders. Lamb and the six jurors signed the report.

The legal language had the measured beat of a drum at a military funeral. Twenty times, in only slightly different words, the report introduced a conclusion with "the Jury find." The report was peppered with stiff phrasing. The jurors found that "the direct

cause of the fall of this mill was the weakness and insufficiency of the cast-iron shoring. That the thinness of the brick walls and their manner of construction…were additional causes, and aided in the general demolition of the building."

The names of only four men appeared in the body of the findings: Albert Fuller and John Woods of the Eagle Iron Foundry, Charles Bigelow of the Essex Company and J. Pickering Putnam of the Pemberton. The owners, past and present, as well as Coolidge, were exonerated passively by the absence of their names. Of the former foundry manager, the jury concluded that "so far as actual defects in the cast-iron pillars existed, the responsibility rests upon Albert Fuller."

If this was a rifle shot of a verdict, a cannon was fired in the last of the nineteen paragraphs of findings:

> *That upon Charles H. Bigelow, being the architect as well as superintendent of this structure, rests all responsibility arising from an insufficient test of said pillars and from any and every defect, weakness, and insecurity apparent in and about the general construction of said building. That the walls were laid under his supervision; that the timbers and floorings were in every respect constructed and located as he originally designed; that the inner supports of cast iron, previous to the erection, had his approval, and were by him adopted as in all parts safe and secure; that such inspection as he required was given to the iron pillars, and that any want of skill in designing, any want of due care and caution in properly testing the different portions of the structure on his part appearing, to that extent rendered him responsible for the direful catastrophe.*

The jury relieved Putnam of guilt because he had consulted Bigelow on every proposed change and received the engineer's approval to act. The jury found the cast iron pintles "were entirely insufficient for the purpose assigned them" and concluded that even "if the pillars in every respect had been properly cast, [they] were insufficient, and the structure consequently unsafe."

Charles Bigelow responded almost instantly. Close observers may have detected a sense of guilt in some of Bigelow's testimony. As if demonstrating his dedication to honor, Bigelow had admitted, "With what I know now, I should…have the columns larger and thicker, and should have tried them with a sledge hammer. I should build the same walls. I should have no hesitation in making the span as wide. If I used pintles, I should have a fillet around under the flange, but I should prefer clasps…The building would have been stronger with three rows of columns."

Now, reading the jury findings, Bigelow was not so accepting of blame. He wrote instead of the work of subordinates and of ideas coming from others and of not remembering his having given approval. And he concluded with a general sadness that could be interpreted as regret more for the loss of pride in his failure to create a model mill than for the deaths of so many people.

Bigelow's response was printed in the *Journal* the next morning. He began, "it is abundantly proved that the bad casting of the iron columns was the main cause of the disaster. Obtained from the sources and in the manner they were, no calculation or

Ugly drawings and damning metaphors
came from the pen of an artist for *Vanity
Fair,* January 28, 1860. *Courtesy of the
Lawrence Public Library.*

allowance of strength would have been of any avail as security. These columns were calculated to bear only one tenth of the breaking weight; and I apprehend that very few engineers in the world would say that a greater margin of security than this was needed."

As for pintles, Bigelow made clear that the plan was Putnam's:

> *My invariable habit was to use the clasp embracing the beam. Although a model of such a pintle is mentioned in the correspondence, that somebody would show to me, I have not the slightest recollection of ever having seen it, and I know that I was never called upon beforehand to determine its strength. Long after all discussion of this system of columns was ended, the columns and pintles, as contracted for and purchased by the owners of the mill, were received in good faith and put into the building, without any special attention being called to the subject of their strength. If, under the circumstances, I ought then to have examined and rejected them, the responsibility for not doing it fairly rests with me. But, after all, it is perfectly clear that the breaking of the flange of the pintle would have had a trifling effect (owing to the mode of placing them in the beams), and could never have caused a column to break when it was properly made.*

In fact, Bigelow asserted, "I cannot now attribute to myself any blame for not causing a more rigid inspection of these castings. I applied, as the testimony shows, all that anybody had ever applied before, and all that anybody would have applied in my place."

The factory's walls, he went on, had stood six years, "absolutely invariable, and as straight as when first erected…It is certain, if they had been far stronger than any mill walls ever built in this country, they would have been overthrown by the destruction of the iron columns."

Bigelow ended his defense with a statement that seems to read something like, "Go ahead, blame me—I think you have the wrong man." He wrote:

> *It seems strange that so general and sweeping a censure as that contained in the last clause of the verdict should have been thrown upon me, although it is stated in a hypothetical form, when so sufficient and manifest a cause for the disaster existed (which everybody knows did actually produce it) in which I acted no part and could not have avoided by any care of diligence which would not have been most unusual and extraordinary…If there are any thinking men, however, sensitive enough to imagine the suffering caused me, in having my name connected at all with this most sad and disastrous calamity, they can also sympathize in the additional regret I feel that a structure which was regarded as a model of excellence in the adaptation of all its parts to the accomplishment of its object should have been whelmed in such a total defeat through the most unlooked for carelessness or dishonesty of a subordinate agent.*

Bigelow had supporters. The *Boston Courier* took the jurors to task: "Having arrived at a probably accurate [cause], they proceed a great deal farther than they are warranted in

Pemberton Mill exterior today shows brick walls like those in original building, suggesting the tremendous force necessary to topple the "monster mill." *Courtesy of Alvin F. Oickle.*

doing, in throwing substantially the whole burden of blame upon one person...The jury appears to have wanted a scapegoat, and for some reason, not apparent on the record, have fixed upon Capt. Bigelow to bear a very undue share of responsibility...as if he had been guilty of that sort of negligence which would amount to an atrocious crime."

Bigelow was an admired neighbor and the *Lawrence American* "can but regret the severity, or more appropriately, the harshness with which the verdict is concluded, which can but grate upon the feelings of those who know the high character and worth Capt. Bigelow has ever sustained."

According to Robert H. Tewksbury's *History of Essex County*, a "more general verdict, however, placed the responsibility fully as much upon the owners [Wood and Fuller] of the foundry from whom the columns were bought, and the agent of the mill [Putnam] who contracted for, purchased, and sent them to the builder."

Newspaper editorialists took sides, often disagreeing openly. An exchange of opinions involved the *New York Herald* and the *Boston Journal*. The *Herald* began: "We...insist that the responsibility of it shall be put where it belongs—upon the wealthy Boston philanthropists who, to save a quarter of a cent in the pound of iron, caused over five hundred persons, white slaves of the North, to be killed, maimed, or wounded." The *Journal* shot back: "The *Herald* distorts the facts. It is true that the pillars, the weakness of which may have caused the disaster, were cast in Boston instead of in Lawrence, because it could be done here cheaper...but there is no evidence that those for whom it was built consulted cheapness, or were reckless of safety."

The jury's findings have been criticized for not explaining *why* a faulty pillar broke and, in domino fashion, all 270 cast-iron columns went down, taking with them the mammoth building they helped hold upright. The reasoning generally held that the factory had stood more than six years without falling, poorly cast columns or not. So why did the huge building collapse on January 10, 1860?

Several investigations have included the possibility that an unexplained event created a condition that set off the collapse of the Pemberton's weight-bearing pillars. Machine breakage and vibration have been suggested. Hayes, writing eight years after the collapse, claimed some "men of intelligence...believe that the primary cause of the calamity was the breaking of a gear...But what caused the fall is as much a mystery today as it was on the day when that jury commenced its laborious, long continued, and utterly fruitless investigation."

Newspaper readers at the time knew about employee Rosanna Kenney's fear that vibration was causing the main building to "rock." Professional studies suggested the same cause as early as January 1860, before the inquest jury had issued its findings, and again twenty years later.

Bigelow, however, would not agree with any argument suggesting vibration as a cause. He stated: "The mill was far more free than usual from vibrations, and in fact did not vibrate at all." The *Journal of the Franklin Institute* wrote: "By the new proprietors, its unusual freedom from vibration seems to have been the only point [about construction] particularly discussed, and this could have been only a subject of congratulation." Isaac Hinckley, superintendent of the Merrimack Company in Lowell, did not go that far,

but he told the jury, "I perceived no more motion in the mill when weaving than is ordinary."

A Massachusetts Institution of Technology professor, J.P. Den Hartog, indicated nearly a century later that mid-nineteenth-century engineers were not likely to understand much about vibrations. He wrote in 1956: "While in 1934 a mechanical engineer was considered well-educated without knowing anything about vibrations, now such knowledge is an important requirement."

In the end, the average person's opinion was as good as any expert's opinion. There were no further inquiries, no criminal court actions. The men involved in creating and managing the Pemberton Mill went about their lives. Lowell, Bigelow, Putnam, Howe, Nevins—none was punished for any actions they had taken, or had failed to take. Compared with the families who were burdened with the finality of death, the decision-makers had been simply inconvenienced.

The Aftermath

"The money changers have fled from their high seats in the temple of our civilization. We may now restore that temple to the ancient truths. The measure of restoration lies in the extent to which we apply social values more noble than mere monetary profit."

—Franklin Delano Roosevelt

The Pemberton Manufacturing Company was out of business by mid-March, 1860. The ruins had been removed and an empty foundation stood where the Pemberton's main mill had been running two months earlier. Co-owner George Howe sold off undamaged cotton stock and partner David Nevins found buyers for the undamaged finished products.

Howe, as treasurer, closed the books and went after the insurance companies. All rejected the initial claims. They reasoned that the mill had collapsed before the fire began. In June, however, the firms agreed to establish a three-member investigations committee to hold hearings in Lawrence. From that came agreement to pay out $93,375 to cover the loss of buildings, machinery and stock in process.

In June, Howe transferred the old financial accounts to a new corporation, the Pemberton Company, and sold his interest to Nevins. Among Nevins's new partners was his father-in-law. Jared Coffin was a former Nantucket sea captain and father of Eliza Coffin Nevins. The Nevinses called home the Methuen mansion they built on the family's original farmland.

With controlling interest his, Nevins ordered construction of a new mill. Within a year, the new Pemberton—resting on the solid original foundation—was up and running. It is still standing in the early years of the twenty-first century—its five floors above the old cellar held there firmly with columns made of thick wood. Captain Bigelow probably knew about the new mill's construction and surely would have applauded the decision to abandon cast iron and use wood.

Nevins's new Pemberton in 1861 had 859 operatives, of whom 650 were female, working at 307 looms and 25,000 spindles. Four of the mill's managerial team remained male: Henry S. Shaw as treasurer, Nevins and his Boston company as selling agent, John E. Chase as agent and Frederick E. Clarke as paymaster. And a woman had advanced to management level. "Miss E.L. Cleason" was listed as cashier.

Wood was used for pillars in the 1860 Pemberton building, still standing, as Captain Bigelow had planned in his original plans and specifications. *Courtesy of Alvin F. Oickle.*

PEMBERTON

COMPANY.

INCORPORATED, 1860.

HENRY S. SHAW, Treasurer,

No. 82 Chauncy Street, Boston.

F. E. CLARKE, Agent.

Miss E. L. GLEASON, Cashier.

COTTON SPINDLES,	28,000
LOOMS,	870
MALES EMPLOYED,	200
FEMALES EMPLOYED,	650

MANUFACTURE

COTTON GOODS

IN VARIETY.

Advertisement under Pemberton's post-1860 ownership lists new administrators with the reappointed agent, F.E. Clarke. *Courtesy of the Lawrence Public Library.*

"The press"—long before newspaper and magazine reporters became grouped as "the media" with broadcast journalists—packed up and departed Lawrence soon after the inquest jury reported. As a news event, the Pemberton story was major everywhere the first few days. After that, it settled into a routine for the duration of the inquest hearings.

Many of the January news reports were preserved in a ninety-six-page book called *The Lawrence Calamity* and published by John J. Dyer of Boston. The work of compiling and editing was performed by *Boston Journal* reporters Samuel W. Mason and E. B. Haskell. In the introduction, they wrote: "Arriving early on the ground, and remaining through the dreadful scenes of the succeeding fortnight, we believe that we have been enabled to select the true from the merely probable, and to give the reader a straightforward and reliable history."

Lawrence's municipal records of the Pemberton tragedy are rather sparse. The city clerk's record for 1860 includes a January listing of the deaths, each attributed to "Fall of the Pemberton Mill." While the range of fatal injuries must have been great, there are no details in these records. The fire department's unsigned record for the day is even shorter and less detailed: "Falling and burning of Pemberton Mills. The loss of lives and property I will not attempt to describe."

Locating and reuniting lost relatives took weeks, in some instances. Correcting the mistakes of identity was no less stressful. Some could be made quickly. For example, the *Boston Journal*, on January 14, followed a new listing of casualties with this correction: "William Keith and Anne McKee, whose names are included in the list of the dead, were only wounded. 'Martha Hughes' in the dead list should have been 'Martin Hughes.' 'Damon F. Ham' in the list of wounded should have been 'Damon Y. Horn.' In the same list, 'George Kodolph' should have been 'George Kradolpher.' In the list of the missing, 'Ellen A. Ham' should have been 'Ellen Ahern.'"

Individual efforts at helping survivors continued, in some cases, for years. The entire town of Rochester, New Hampshire, opened its heart to the family of Maurice Palmer, the man whose death came from internal injuries, not from attempted suicide.

For weeks, the curious came to Lawrence. Among visitors March 2 were a presidential candidate touring New Hampshire, and his son, Robert Todd Lincoln. Abraham Lincoln wrote his wife, Mary Todd Lincoln, "We came down to Lawrence—the place of the Pemberton Mill tragedy—where we remained four hours awaiting the train back to Exeter."

On March 4, the day that Lincoln was writing, the Reverend Caleb E. Fisher was conducting a service at Bellevue Cemetery for thirteen Pemberton employees whose bodies had been burned or mutilated beyond recognition. Erected over the mass grave was a stone monument twelve feet tall. On one side is the inscription: "In memory of the unrecognized dead who were killed by the fall of the Pemberton Mill, January 10, 1860."

An accurate final count of casualties is not likely ever to be known. The Pemberton and City of Lawrence records in the American Textile History Museum at Lowell indicate that 96 employees were killed in the disaster. Newspaper stories in the days after the disaster listed 83 deaths and later 5 deaths from injuries, a total of 88 dead and

missing. Of 275 who were hurt, 116 were listed with serious injuries. By that count, 307 escaped unhurt from the collapsing factory. In addition, 248 Pemberton employees were considered "not in danger" by reason of working in outbuildings or absent that day.

Considering that hundreds were injured, remarkably few survivors carried lifetime disabilities. There were apparently only two amputations: a forearm of Michael Daley and a hand of Edward W. Colbert. Two young women were deemed the most seriously injured. The Relief Committee provided Maria Hall and Augusta L. Sampson with lifetime annuities, respectively $350 and $400 a year.

In February 1861, Storrow issued a "final report" for the Relief Committee. Receipts totaled $65,834.67. The summary shows $51,472.99 "disbursed for relief." That sum included $5,057.07 "for articles for general distribution, bought in very large quantities, and given out mainly through the City Missionary—and for other expenditures not directly chargeable to particular cases relieved" and $1,404.78, "for assistance employed in all ways by the Committee, as Clerk, Inspectors, City Missionary, stationery, telegraphing, postage, and all other expenses."

Of the remaining $14,361.68, the committee had paid the Massachusetts Hospital Life Insurance Company $14,000 "for annuities in trust" and "placed in hands of George P. Wilson, City Missionary," the few hundred dollars remaining "to be applied where most needed."

The Pemberton name and the tragedy have been remembered into a second century in many ways. Each new generation of local historians has passed along information and area newspapers provide anniversary reports. At least half a dozen poems have been published to commemorate the mill's collapse. A poem with twenty-four verses was written by Leonard Hathaway Beal, entitled, "Lines on the Catastrophe at Lawrence on Tuesday, January 10, 1860." From it came a song with a verse celebrating the feat of Olive Bridges's escape through the elevator shaft.

Composer's ballad saluted Olive Bridges's feat. *Courtesy of the Lawrence Public Library.*

Disaster display at Lawrence Heritage State Park. *Photo by Jim Beauchesne. Courtesy of Lawrence Heritage State Park.*

Exhibits have been arranged for the public by the Historical Society of Lawrence, the Lawrence Public Library and the Lawrence Heritage State Park. All of these facilities have books and papers reporting the Pemberton disaster. The library's collection includes newspaper clippings prepared thirty years later by Arthur D. Marble. The state park, on property called "Pemberton Park," has what may be the last remaining segment of the faulty cast-iron pillars. Dr. Lamb, who conducted the inquest in 1860, told a newspaper reporter in 1900 how pieces of the last pillar came to leave Lawrence. The reporter wrote: "The defective column the coroner preserved, but it was sawed in pieces, from time to time, and is distributed throughout the United States. The last piece he carried to Worcester, for exhibition purposes, and it has not been returned."

In 1973, a reporter equated the Lawrence tragedy to "the Great Chicago Fire, the San Francisco Earthquake and Boston's Cocoanut Grove Fire." The Pemberton collapse may have developed a similar contemporary public interest but, unlike the others, the Lawrence events did not lead directly or immediately to laws protecting people in their workplaces. Melvyn Dubofsky's study, *Industrialism and the American Worker, 1865–1920*, reports: "From 1880 to 1900, 35,000 workers were killed annually and another 536,000 were injured." He cites coal mining, with 2,000 deaths a year from 1905 to 1920, and "a similar sort of human destructiveness" on the railroads, with nearly 1 of every 400 killed in the year 1901.

In essays published in 1990, about Massachusetts's industrialization, two historians commented on the role the Pemberton Mill collapse has had in the years since 1860. Kenneth Fones-Wolf, co-editor of the anthology, wrote about the immediate impact of the disaster on new construction. Clarisse A. Poirier's essay reviewed developments over the following decades and suggested the Lawrence events contributed to the eventual improvement of industrial safety standards.

Labor historian Patricia A. Reeve has traced the early failed attempts of the Massachusetts General Court at enacting legislation to require and enforce safety in factories. Action began the day after the Pemberton Mill's collapse when Representative John C. Tucker of Boston successfully moved to instruct the House Committee on the Judiciary to "consider the expediency of providing by law for the inspection" of factories. "By 1860," Reeve writes, "the Massachusetts judiciary and legislature had intervened in every sphere of life save that of industrial relations, with the notable exception of Commonwealth v. Hunt (1842) [which] established workers' liberty of association by ruling that trade unions did not constitute a conspiracy."

Five weeks after being charged, the House Committee on the Judiciary had prepared and sent to the House for action Bill no. 83, "to Provide for the Security of Public Buildings and Bridges." Representatives Tappan Wentworth of Lowell and Arthur A. Putnam of Danvers were instrumental in this progress. Another six weeks passed, and on March 29, the House-approved bill was moved to the upper chamber of the Legislature. Senator J.F.B. Osgood of Salem got behind Bill 83 and the Senate assigned the proposal to its Committee on the Judiciary. Such swift action was rare. Only a few working days later, on April 3, the committee referred the bill to the full Senate with its recommendation for adoption. The Senate also moved with speed. It granted a second reading but the following day refused the third reading necessary for enactment.

The bill died. Reeve concludes: "Because extant records shed no light on the Senate's contradictory actions, we are left to conjecture that, absent constituent support for the bill, state industrialists successfully quashed it."

Reeve continues: "It is striking that public consumption of Lawrence disaster reportage did not compel Massachusetts' readers to campaign for laws that might have prevented a recurrence of the disaster. [Although] state residents persisted in expressing their civic ideals and aspirations through petitioning…virtually no petitions were filed with the Massachusetts General Court during the disaster's aftermath."

John Frederick Potter has outlined the "timing of the kickoff of reform": "By 1860 the courts had temporarily settled the major legal issues surrounding industrial accidents and employers' liability. [However] no safety legislation was passed until 1877…and it was not until 1879 that a suitable body to enforce all factory legislation was established." That body was the state constabulary and "as a result of this decision every factory inspector in Massachusetts until 1912 was to be a state policeman."

Another major Massachusetts industrial accident in the next century contributed to more progressive changes. The structural failure of a gigantic metal tank in Boston's North End in 1919 "influenced the adoption of engineering certification laws in all states, as well as the requirement that all plans for major structures be sealed by a registered professional engineer before a municipality or state would issue a building permit," author Stephen Puleo reports in his account of what came to be called "The Great Boston Molasses Flood."

Puleo also writes that the 1919 tank disaster, in which 21 people were killed and 150 injured, proved that "a corporation *could* be made to pay for wanton negligence of the sort that led to the construction, with virtually no oversight or testing…The feeling that Big Business could not be trusted to police itself grew stronger in the late 1920s and 1930s. Citizens demanded, and got, broader regulations and government oversight in the marketplace" (emphasis added by Puleo).

William Greider, introducing the 2001 reprint of Leon Stein's account of the 1911 disaster, calls the Triangle Shirtwaist Factory fire in Lower Manhattan "a galvanizing moment in American history…New York and a few other progressive states enacted landmark laws establishing new social standards and regulatory rules for industrial enterprise…But it was twenty-five years before the federal government acted."

The Triangle fire took the lives of 146 garment workers, all of them females. Unable to escape the flames because of locked doors on the eighth, ninth and tenth floors, many of them jumped to their deaths on the sidewalks. The nation was shocked, much as it had been a half-century earlier with the Pemberton disaster. The "golden era in remedial factory legislation" began three months after the Triangle fire when the New York Legislature established a Factory Investigating Commission. Over its four-year term, the commission's actions led to thirty-six New York State laws. The chief counsel, Abram I. Elkus, declared: "The so-called unavoidable or unpreventable accidents which, it has been said, were once believed to be the result of the inscrutable decrees of Divine Providence are now seen to be the result in many cases of unscrupulous greed or human improvidence. It is the duty of the state to safeguard the worker not only against

Henry K. Oliver. *Courtesy of the Lawrence Public Library.*

the occasional accidents but also the daily incidents of industry; not only against the accidents which are extraordinary but also against the incidents which are the ordinary occurrences of industrial life."

The worst mine fire in United States history, in 1909 in Cherry, Illinois, moved the country closer to worker's compensation laws. Karen Tintori has documented the Cherry Mine catastrophe, in which 259 men and boys perished. Tintori cites Maryland legislation of 1902 "to protect injured workers" and adds, "but the concept of a comprehensive worker's compensation act did not take firm hold until Cherry." Reeve adds that the period 1820–1911 "began with experimental capitalization of labor and concluded with state enactment of workmen's compensation."

Slowly, the march toward workplace safety continued. Step by step with it, the nation was also recognizing that the terrible social imbalance the factory system had created needed to be addressed. Reeve explains: "The events of January 10 called into question workers' capacities for [social respectability and civic equality]. In short, workers' social and physical vulnerabilities were not only markers of mill owners' unbridled avarice, but also they called into question the respectability of those victimized by it."

Credit for more than a little of the change to recognize the worth of all humans in the workplace should be given to Henry K. Oliver, one of the leaders in Lawrence's struggle during the Pemberton experience. Oliver had served the city as school superintendent, the Lawrence area as a state representative and Massachusetts as attorney general. But perhaps Oliver's greatest legacy comes from the only two events in his life that he recognized as failures. He was fired twice, to use the term loosely, because his dedication to improving working conditions came in conflict with mill owners' and state officials' management philosophy. In that sense, he was himself a victim of Big Business.

Oliver was dismissed as agent of the Atlantic Mills in Lawrence in 1858. He had gone so far as to plant flowers and bushes in open areas around the mill, and had installed hot-water showers for the workers. When he was let go, several overseers cited thoughtful and progressive provisions he had arranged for workers. Oliver went on, Reeve reports, to "develop a reputation as a labor law reformer during the late 1860s and 1870s. On November 13, 1869, Oliver assumed his duties as the head of the newly established Massachusetts Bureau of Statistics on Labor. By 1900, the Commonwealth emerged as a national pacesetter in the development of labor law reform and the requisite state infrastructure."

In 1873, however, Henry Oliver was not reappointed to head the bureau. Again, it seems, he had "struck at the roots of great evils, or erroneous opinions in society, and so awakened deep hostilities," a biographer has written. "[H]e laid bare the tenement-house system of Boston and also made it plain that the savings banks of the Commonwealth were largely the storehouses in which the well-to-do people preserved their plenty out of the reach of taxation. Inevitably a storm was raised against him." Oliver would be long dead when Franklin D. Roosevelt began "the measure of restoration," but Oliver's work had not been wasted. Roosevelt was to tell his first inaugural audience, a half-century later, "The money changers have fled from their high seats."

Commemorative services were conducted in 1960, on the 100th anniversary of the Pemberton disaster. A group gathered at the Bellevue Cemetery mass grave.

Massachusetts Commissioner of Labor John A. Callahan said: "In a city that was later to become the greatest textile center in the world, how ironic it was that when tragedy did occur, textile employees were the victims. How far our city, state, and nation have progressed in the past one hundred years since."

The final word may have been delivered in 1901, in a story in the *Telegram* written by John Kelleher, a junior at Lawrence High School. He provided these lines:

> *What a fall was there, my countrymen!*
> *Suis cladem illus noctis, quis funera fendo explicet?*

The Latin text has been translated as: "Who can explain the tragedy of that night, the burials, even to themselves?"

Bibliography

There must be tens of thousands of books that touch on that period called "the industrial revolution." Historians and narrative writers alike have covered the period and the people, coming at the broad subjects through such diversified and specific fields as biography and engineering. I do not have space to list most of the books I have consulted.

Two major sources for information are in the Merrimack Valley. The American Textile History Museum in Lowell, Massachusetts, houses many of the Pemberton Mill's official corporate records and the Lawrence Public Library archives have newspaper clippings from the time of the 1860 mill collapse, notably the *Collection of Arthur D. Marble*, dated May 8, 1890. Each also has available published material important to a study of the valley, the founding of industrial cities and the development of textile manufacturing.

Here are a few of the books I found most helpful:

Butler, Benjamin F. *Butler's Book: A Review of His Legal, Political, and Military Career*. Boston: A.M. Thayer & Co., Book Publishers, 1892.

Cole, Donald B. *Immigrant City: Lawrence, Massachusetts, 1845–1921*. Chapel Hill, NC: University of North Carolina Press, 1963.

Dorgan, Maurice B. *History of Lawrence, Mass*. Lawrence, MA: published by the author, 1924.

———. *Lawrence, Yesterday and Today, 1845–1918*. Lawrence, MA: Dick and Trumpold, Publishers, 1918.

Dunwell, Steve. *The Run of the Mill: A Pictorial Narrative of the Expansion, Dominion, Decline, and Enduring Impact of the New England Textile Industry*. Boston: David R. Godine, Publisher, Inc., 1978.

Fones-Wolf, Kenneth, and Martin Kaufman, eds. *Labor in Massachusetts: Selected Essays*. Westfield, MA: Westfield State College, 1990.

Ford, Peter A. "Father of the Whole Enterprise: Charles S. Storrow and the Making of Lawrence, Massachusetts, 1845–1860." *The Massachusetts Historical Review* vol. 2 (2000).

Fremmer, Richard M. "A Short Biography of David Nevins, His Family and Estates." Unpublished paper. Methuen, MA: Nevins Library, 1955.

Geerlings, Gerald K. *Metal Crafts in Architecture*. New York: Charles Scribner's Sons, 1957.

Hayes, J.F.C. *History of the City of Lawrence*. Lawrence, MA: E.D. Green, 1868.

Hurd, D. Hamilton (compiler). *History of Middlesex County, Massachusetts: With Biographical Sketches of Many of its Pioneers and Prominent Men*. Philadelphia: J.W. Lewis & Co., 1890.

Mason, Samuel W., and E.B. Haskell, eds. *An Authentic History of the Lawrence Calamity*. Boston: John J. Dyer & Co., 1860.

Molloy, Peter M., ed. *The Lower Merrimack River Valley: An Inventory of Historic Engineering and Industrial Sites*. North Andover, MA: Merrimack Valley Textile Museum, 1978.

Perry, Gregory J. *The Old Mill and the Spree: The Simple Lure of Opportunity in the Catching-on of Textile Manufacturing Cities in Northern New England; Episodes in the Urban Geneses of Lowell and Lawrence, Massachusetts, 1821-1853*. Unpublished master's degree thesis, 1990.

Poirier, Clarisse. *Pemberton Mills 1852-1938: A Case Study of the Industrial and Labor History of Lawrence, Massachusetts*. Unpublished dissertation, 1978.

Tewksbury, Robert H. *Standard History of Essex County, Massachusetts*. Boston: C.F. Jewett & Company, 1878.

Wadsworth, Horace A. *Quarter-Centennial History of Lawrence, Massachusetts*. Lawrence, MA: Eagle Press, 1868.

Other sources included several 1860 issues of the *Journal of the Franklin Institute of the State of Pennsylvania, for the Promotion of the Mechanical Arts* and *Vital Records of Lawrence, Massachusetts to the End of the Year 1859*. Salem, MA: Essex Institute, 1926.

Many newspapers and magazines are available on microfilm at University of Massachusetts–Boston and the American Antiquarian Society. Among the periodicals

most helpful were the *Boston Advertiser and Daily Bee*, the *Boston Herald*, *Frank Leslie's Illustrated Newspaper*, *Harper's Weekly*, the *Lawrence American*, the *Lawrence Courier*, the *Lawrence Eagle Tribune*, the *Lawrence Sentinel*, the *New York Times* and *Vanity Fair*.

About the Author

Alvin F. Oickle has had careers in journalism as a newspaper reporter and Associated Press feature writer; as a writing instructor at the University of Massachusetts in Amherst; as a student periodicals adviser at UMass and at Stony Brook University in New York; in broadcasting with New York and Massachusetts radio stations, and as an author. He lives now in Florida, where he writes nonfiction books based on nineteenth century history, including *Jonathan Walker: The Man with the Branded Hand*, published in 1998, and *The Pemberton Casualties*, being published in the summer of 2008. He has begun work on a biography and a battle story with the Spanish-American War as the focus.

Visit us at
www.historypress.net